PICTURE PERFECT
SOCIAL MEDIA

First Published in the UK in 2014 by
Apple Press
The Old Brewery
6 Blundell St
London, N7 9BE
www.apple-press.com

10 9 8 7 6 5 4 3 2 1

ISBN: 978-1-84543-550-9

Commisioning Editor: Isheeta Mustafi
Editor: Ellie Wilson
Assistant Editor: Tamsin Richardson
Art Director: Lucy Smith
Design concept: Emily Portnoi
Layout: Lucy Smith & Michelle Rowlandson
Cover Design: Lucy Smith
Illustrations: Sarah Lawrence & Rob Brandt

Manufactured in China

IMAGE CREDITS
Front cover: Jennifer Young.
Back cover (L-R): Tara O'Brady; Michelle Lau; Leila Peterson.

PICTURE PERFECT
SOCIAL MEDIA

A HANDBOOK FOR STYLING PERFECT PHOTOS FOR POSTING, BLOGGING AND SHARING

APPLE

CONTENTS

SECTION THREE
THE TECHNICAL STUFF

INTRODUCTION

In recent years, the act of sharing visual content through social media, whether it be via blogging or photo-sharing apps or websites, has caught on exponentially. This is due to the accessibility of current camera equipment, the rapid improvement and use of smartphones as cameras, and the readily available and affordable tools to help create good images for sharing. As such, the quality of imagery being shared worldwide has improved dramatically.

This book aims to help improve your photography skills through practical guidelines and shared knowledge from creatives with a unique eye and perspective, who have had success in growing their social network in an overly saturated image-centric online world. The first section of the book features essential information on choosing the right camera for you, how to create great shots and the etiquette of photography. The second section then comprises seven chapters written by prominent lifestyle bloggers, giving you an insight into their working methods as well as tips and advice on shooting all kinds of subjects—from food, to pets, to fashion. Finally, the third section talks you through the technical side of photography, so you know how to edit, store and share those picture-perfect shots.

If you want to learn more or have ever been curious about where to begin with photography, look no further. This book will teach you the skills you need to stand out in an ever-evolving and visually creative online community.

SECTION ONE

UNDERSTANDING YOUR CAMERA

CHAPTER 1

WHAT YOUR CAMERA CAN DO

It is possible to take good photos without spending a lot of money on equipment. Good photography is less about your camera and more about your eye, your ideas and knowing how to express them. Of course, a nice camera can be helpful in certain conditions, but it is best to focus on creating a strong picture first and foremost, and doing the most you can with what you have.

This chapter will cover basic camera types as well as their advantages and limitations, to help you decide what may work best for your lifestyle and the kind of pictures you want to take. In addition, this chapter will also discuss automatic and manual settings, which will help give you a better understanding of how your camera works and what you can do to improve the quality of your photos.

CAMERA TYPES

There are so many cameras on the market that it can be overwhelming trying to choose one that's right for you. Below are five basic camera types to give you an idea of what is available and help you decide which is the best fit.

CAMERA TYPES—THE BASIC RUNDOWN

Point-and-shoot (see pages 12-13)
- Simple to use
- Lightweight
- Fixed lens
- Automatic settings

Digital Single-Lens Reflex (DSLR) (see pages 14-15)
- High-quality images and video capabilities
- Interchangeable lenses
- Complete manual control

- **Analogue (see pages 16-17)**
- Uses film
- Manual controls

Smartphone (see pages 18-19)
- Simple to use
- Easily accessible
- App options for editing photos

Toy (see pages 20-21)
- Simple to use
- Uses film
- Inexpensive
- Can create artistic effects

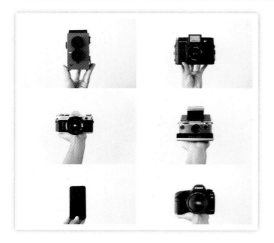

WHAT TO THINK ABOUT WHEN CHOOSING A CAMERA

When choosing a camera, there are a few questions you can ask yourself before making an investment. These questions may help you determine what camera would work best for what you do and need:

- What will I be taking pictures of?
- Where will I be shooting? Indoors? Outdoors?
- What will the images be used for?
- Will the camera be used a lot for travelling or am I on the go frequently?

POINT-AND-SHOOT

Point-and-shoot cameras work well for general photography and are easy to learn how to use. They have non-interchangeable fixed lenses and are generally less expensive than DSLR cameras. This camera type may be a good choice if you are just starting out and need to learn the basics of photography.

Tamsin Richardson

USING POINT-AND-SHOOT CAMERAS

A point-and-shoot camera is a great option for on-the-street-style fashion photos, travel photography, and landscapes, as it is ideal for:

Quick candid shots
- Lightweight and easy to grab out of your bag quickly.
- No fuss over changing lenses.
- Automatic settings.

Getting a general idea of a place or space
- Large depth of field, which means everything in the image will be in focus.
- Can be used for visual note-taking if something needs to be remembered in a restaurant or shop.

SEE ALSO

 Automatic p. 23

ADVANTAGES

There are many advantages to owning and using a standard point-and-shoot camera. They can be used indoors or outdoors, and are a good option if you are looking for something compact with simple functions and automatic settings. Point-and-shoot cameras come in handy if you like to shoot quickly or discreetly, are frequently on the go or like to pack light.

With automatic settings, the camera essentially thinks for you and chooses the best settings for the situation that you are in. This may help you concentrate more on composing and taking a shot that you want. Automatic systems may be a plus if you are a beginner and need to focus on capturing an image quickly.

LIMITATIONS

The automatic settings of point-and-shoot cameras work well if you are constantly in ideal weather and lighting conditions, or if you don't need to adjust the aperture or shutter speed often. This, however, does leave you with less creative flexibility when shooting. Point-and-shoot cameras cannot be modified or upgraded with different lenses. Additionally, they have a large depth of field, which means everything will be in focus. This is limiting if you want to take pictures that focus on a certain subject (such as portraits, details or a specific item).

13

DSLR

A digital single-lens reflex (DSLR) camera is a great option to consider for capturing high-quality images and video that can be uploaded to most blogs and social media. DSLRs come with automatic modes for easy use, but also have complete manual controls and interchangeable lenses, which give the (skilled) user a greater ability to work in a variety of settings and environments.

HIGH QUALITY OF IMAGES AND RAW MODE

The DSLR's potential to produce high-quality images is due to the high number of megapixels as well as the large image sensors housed within the body.

DSLRs can also shoot in RAW mode, where detailed data is transferred directly from the camera's image sensor, resulting in large images that are not processed by the camera. This gives more flexibility when post-processing, which is a definite advantage if your photos don't turn out exactly how you want them to.

VIDEO

The modern DSLR is designed not only to capture high-quality images, but high-quality video as well. Creating videos for sharing may be beneficial to communicate on a more personal level with your readers, share tutorials or interviews, and add variety in general to a blog to supplement posted images and text.

INTERCHANGEABLE LENSES

Image quality is highly dependent on the type of lens you use. There is a wide range of lenses available for different DSLRs. They vary in quality, focal lengths, aperture and zoom abilities.

MANUAL CONTROLS

In addition to automatic modes for easy shooting, one of the most notable things about using a DSLR is the amount of control you have with the manual settings. Changing the ISO, aperture and shutter speed allows for more flexibility and creativity, and can completely change the look and feel of a photo.

IS A DSLR BEST FOR YOU?

A DSLR is generally the best type of camera all around for shooting a vast array of subjects and places, but there are a few reasons why it might not be best for you:

High price points DSLRs are expensive. Upkeep and buying multiple lenses and accessories can get pricey.

Large and bulky DSLRs may not be the easiest to carry around or shoot with quickly/discreetly.

Complexity Shooting in manual mode takes time to learn and master.

SEE ALSO

ISO p. 29

Aperture pp. 30–31

Shutter Speed pp. 32–33

ANALOGUE

Although digital cameras are prevalent, there has been a recent resurgence in the popularity of analogue cameras. Analogue cameras are non-digital cameras that use film—basically what we used to use before digital cameras existed. There are many photographers that have never made the switch to digital cameras, as well as some that are going back to using film cameras.

The Great Romance Photography

LIMITATIONS

The main limitation with using an analogue camera is that you can't access your images immediately. This can be tricky when you are just starting to take photos as you will often have to wait to see the results of your shots and may forget your settings or what you did exactly. You can also only take a certain number of shots, which can be limiting if you're trying out new settings or techniques. Film can also be costly, so isn't always ideal to use when you are learning something new as much of it may be wasted. Because of this, starting with a digital camera may be the way to go if you are a beginner.

The Great Romance Photography

USING ANALOGUE CAMERAS

Analogue cameras are particularly suited to shooting portraits, interiors, special events and travel photography. They are ideal for:

- Creating photos with the unique look of film that digital doesn't produce.
- Styling props for a shoot or vignette.
- Creating a rustic, handmade feel.
- Joining groups of other analogue photographers on social media sites like Flickr.

ADVANTAGES

The advantages of using film versus digital include warmer colours in images, more true-to-life skin tones, a beautiful natural film grain and less time post-processing. There is also the thrill of surprise and anticipation when shooting film and having to wait for it to be processed. Using film takes a lot of patience, but the end result is very gratifying if you know your way around the camera.

SEE ALSO

 Toy Cameras pp. 20–21

SMARTPHONE

Smartphone cameras are becoming increasingly popular and are gradually replacing point-and-shoot cameras because of their convenience, capabilities and simplicity. Not only are smartphone cameras easy to use for taking photos, it is also very easy to upload and share these photos on social media.

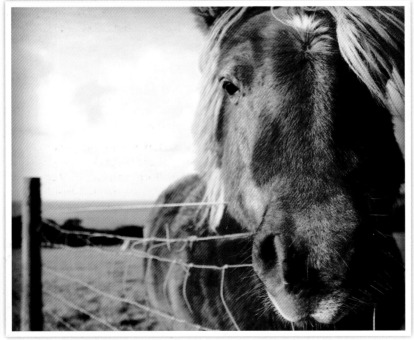

Tamsin Richardson

ADVANTAGES

Smartphones are the go-to camera for many. If you own one, chances are it is close by most of the day. For regular bloggers, this is helpful because you never know when something from your daily life will spark an idea for a post. There are numerous photo-editing apps available that can transform a simple image. You can change things such as the exposure, contrast, saturation, sharpness, etc. Filter apps, such as the popular sharing app Instagram, are also widely available, and can create professional-looking snapshots in seconds. Video apps, like Vine, also allow you to make the most of the smartphone's video capabilities, making video easy to capture and just as easy to share.

USING CAMERA PHONES

As camera phones are so versatile, they are suited to many different genres of photography, including on-the-go street-style fashion photos, travel photography, landscapes, food photography and for taking photos of pets and kids. They are great for:

Quick candid shots
- Quick and easy accessibility
- Easy to shoot discreetly
- Good for visual note-taking

Travel and outdoor photography
- One less thing to worry about on a trip
- Protective and waterproof cases are available for more intense outdoor activities

To supplement a DSLR
- Having the option to choose between using a smartphone or a DSLR may be ideal

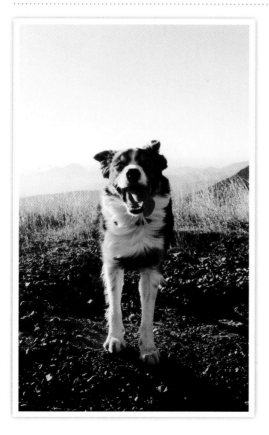

LIMITATIONS

The main limitation with using smartphone cameras is that the images they produce can be poor in quality or small in size. Looking at images on your phone may not reveal these issues because the viewing screen on the phone itself is often limited in size.

Another limitation is that because smartphone cameras are oversimplified, you don't have a lot of control in terms of manual settings while shooting. Apps typically allow you to change an image after it's taken, but the changes you can make while taking a picture are very minimal in comparison to what can be done on a DSLR.

SEE ALSO

 DSLR pp. 14–15

 Understanding Print Quality p. 162

TOY CAMERAS

Toy cameras are simple and easy to use. They are known for being fairly inexpensive and have the ability to create artistic, whimsical and unexpected images. With toy camera images, beauty is really in the eye of the beholder—that's the great thing about them and what they produce. You can forget technicalities and have fun!

USING TOY CAMERAS

Toy cameras suit all kinds of photography. They are particularly ideal for:

Showing a unique perspective
- Toy cameras photograph like no other—they really expose photography in a new light.

Mixing things up
- Supplement regular DSLR images with toy camera images for versatility in your posts.

Travel photography
- Lightweight and compact
- Inexpensive way to create memories

Photographing movement
- A toy camera such as the SuperSampler captures movement in a way that no DSLR can.

WHAT CAN A TOY CAMERA DO?

Toy cameras are made out of cheap materials such as plastic and inexpensive metals, but they are still fully functional and can take great pictures. Most of them use film. Some of the effects that they are known for creating include light leaks, vignetting, blurring, saturated or overly contrasted colours and multiple images per frame—basically the opposite of what traditional photography considers 'good'. Toy cameras have been so popular that there is even a movement and community inspired by them called Lomography.

For blogging, images created by toy cameras may be a good way to change things up and keep your audience engaged. With these types of cameras, not much thought has to be put into taking shots—it is an offbeat and fun way to create and can be quite inspiring.

Diane Leyman

TYPES OF TOY CAMERAS

Some of the popular toy cameras out on the market are the Diana, the Fisheye and the SuperSampler (there are many more!). The Diana creates dreamy and saturated images and is one of the bestselling toy cameras out at the moment. The Fisheye takes 170-degree photos. The SuperSampler snaps four sequential images in one frame. They're unique in that they all produce fascinating one-of-a-kind 'artistic' images.

SEE ALSO

 Analogue pp. 16–17

CAMERA SETTINGS

Point-and-shoot and DSLR cameras have many basic settings and modes to choose from. By switching these modes and adjusting camera settings according to the environment you are in or what you are shooting, you can change and improve the outcome of your images.

DIGITAL CAMERA MODES

On a point-and-shoot camera, modes are geared towards more automatic settings for particular subjects or situations, such as portrait, action or sports, landscape, night-time, etc. When one of these modes is selected, the camera changes settings to what could potentially work best for what you are shooting.

Modes on lower-end DSLRs have a combination of both manual and automatic settings. This is beneficial because there is more flexibility when it comes to shooting in different environments. These DSLRs are a good middle ground choice if you enjoy shooting on auto but want to learn and understand how to shoot in manual mode as well.

For professional-grade DSLRs, the mode options are primarily manual, which include aperture priority, shutter priority, full manual, etc. These modes provide the most flexibility, and you have the ability to completely change the look of a scene while shooting.

AUTOMATIC

Shooting in automatic mode means the camera chooses settings for you based on the light it senses and the environment you are in. This is beneficial when you are just starting out or are learning a new camera system. Most cameras have at least one automatic mode option, but there are many automatic mode choices on point-and-shoot cameras and lower-end DSLRs

Portrait

Action/sports

Landscape

Night scene

Night portrait

Macro

AUTOMATIC MODES

Portrait The camera uses the lowest aperture so that the background will be blurred and the subject will be in focus. This mode works best on one subject.

Action This mode is used for capturing movement or moving objects by using a fast shutter speed. A fast shutter speed will freeze movement, and is effective for shooting subjects like kids or pets, who are likely to be running around.

Landscape Opposite of portrait mode, the camera uses a high aperture setting so that the foreground and background is all in focus. This mode works best on wide scenes.

Night scene Best with a flash, night scene mode is used to photograph low-light scenes with a slower shutter speed.

Macro This mode is used to capture details of a subject when taking close-up pictures and works best for small objects or features, like small pieces of food or clothing details.

SEE ALSO

 Point-and-shoot pp. 12-13

SEMI-AUTOMATIC

Shooting in semi-automatic mode means the camera chooses partial settings for you based on the light it senses and the environment you are in. There is some flexibility when shooting in these modes and they can be helpful when you want to focus on only changing one thing at a time.

Shannon Moore

LIMITATIONS

Cameras are pretty smart when it comes to semi-automatic modes, but sometimes they will sense light incorrectly and your exposure may be off. Therefore, it is very important to constantly check your images to make sure the camera is choosing settings that create a look that is desirable to you.

Another limitation may be if you want to create 'artistic' images—over or under exposing an image, capturing more movement, blurring your subject in a photo, etc. Shooting in full manual mode may be the only option for this because you are able to change and adjust each and every setting.

SEMI-AUTOMATIC MODES

Aperture priority (A or AV) In this mode, you have the option of changing the aperture, which affects how much of your image is in focus and how much is blurred. When the aperture is adjusted, the camera will adjust the shutter speed to create a proper exposure.

Shutter priority (S or TV) This mode is similar to AV except you have the option of changing the shutter speed (how long or short the shutter stays open) instead of the aperture. When the shutter speed is set, the camera will adjust the aperture to create a proper exposure.

Program (P) In program mode, the camera calculates and chooses both the aperture and shutter speed to create a (proper) exposure. This differs from fully automatic mode because you still have control over the flash settings, white balance and ISO, which can all be set manually.

ADVANTAGES

Semi-automatic modes enable you to shoot faster because there is only one adjustment for you to think about changing—either the aperture or the shutter speed. The seconds you save allowing the camera to adjust the remaining settings to achieve good exposure can be all the difference needed to create a desired image. This means shooting in semi-automatic is good for capturing candid images of pets or kids, as well as for travel or event photography, where you are likely to have to react quickly to a special moment.

SEE ALSO

Camera Exposure p. 28

ISO p. 29

Aperture pp. 30–31

Shutter Speed pp. 32–33

White Balance pp. 40–41

MANUAL

Using manual mode (M) means you have complete control over all settings when taking pictures. Shooting in this mode gives you a lot of creative freedom and can help you achieve desirable photos that match your vision. Learning the ins and outs can take some time, but the end result is worth it—you will have a better understanding of how your camera works and will also have a lot more flexibility when creating.

MANUAL SETTINGS

The three main settings that can be changed while shooting in manual include: ISO, aperture and shutter speed. These settings control your exposure and are often referred to as the 'exposure triangle'. They work closely together to help create good exposure.

Depending on what you are trying to achieve in your image, the ISO, aperture and shutter speed are being constantly adjusted.

SEE ALSO

Camera Exposure p. 28

ISO p. 29

Aperture pp. 30–31

Shutter Speed pp. 32–33

CAMERA EXPOSURE

Exposure is the amount of light that is let in by your camera's sensor when taking a picture. Understanding exposure and how to change it can help improve your photography. If a shot is overexposed, the image created will be washed out. On the contrary, if a shot is underexposed, the image created will appear dark. Achieving the correct exposure when a picture is taken will save you time when post-processing.

ELEMENTS OF EXPOSURE

Three elements that determine exposure are:

ISO The film speed or the sensitivity of the camera's sensor to light.

Aperture The opening in the lens that controls depth of field.

Shutter speed The length of time the shutter stays open.

LIGHT METER

Most, if not all, current cameras have a built-in light meter that can aid in finding the correct exposure for your images. Light meters measure the amount of light that is let in when taking a picture, and will then calculate and suggest an 'ideal' exposure. It is beneficial to have a basic understanding of exposure because light meters can occasionally sense light incorrectly.

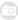
ISO

Remember when you had to choose film speeds for your camera before the digital camera came into existence? ISO refers to the level of sensitivity of your camera to light, and is the digital version of what we used to know as film speed. It is adjustable and very helpful to change when shooting in different lighting situations. ISO is the first element that determines exposure.

Left to right: ISO 100, ISO 200, ISO 400

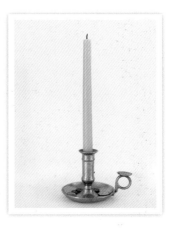

ISO RANGE

The ISO range is broad and can be anywhere from 100-24,000, depending on the type of DSLR you have. A low ISO will make the exposure of an image darker, and a high ISO will make the exposure of an image brighter. The ability to change the ISO is especially beneficial in low-light conditions.

CHANGING THE ISO

It is ideal to shoot at the lowest ISO setting (100), especially when a lot of light is available. However, if shooting on an overcast day or indoors with low light, you may need to adjust to a slightly higher ISO to create images that are exposed correctly. The downfall of shooting with higher ISO settings is that it can add unwanted grain to your images.

SEE ALSO

Aperture pp. 30–31

Shutter Speed pp. 32–33

APERTURE

If you've ever wondered how to achieve a blurry background with an in-focus subject, adjusting the aperture is your answer. The blurred out area in a photo is also known as 'bokeh'. Aperture is the second element that determines exposure.

WHAT IS APERTURE?

Aperture is the size of the hole in a lens in which light passes through. It is measured in 'f' numbers, also known as f-stops, and is adjustable depending on the lens you use. The lower the f-stop (for example f/1.2, f/1.4 or f/2.0), the larger the hole in the lens is, which means a lot of light is let in. In opposition, the higher the f-stop, the smaller the hole in the lens is, thus letting in less light.

WHAT WILL CHANGING THE APERTURE DO?

Changing the aperture can affect how much of your picture is blurred out and how much of it is in focus. This is also known as depth of field. The higher the f-stop, the more depth of field there is, which in turn means more of your image will be in focus. This is ideal for shooting landscapes because the entire scene will be visible and sharp.

Lower f-stops are ideal for portraits or shooting objects because less of what is in the image will be in focus—the foreground or subject you focus on will appear sharp and the background will be blurred. Shooting with low f-stops creates images with less depth of field.

Top to bottom: f/7.1, f/2.8, f/1.8

MAXIMUM AND MINIMUM

The maximum and minimum an aperture can be set to is dependent on the type of lens used. Every lens is labelled with its lowest f-stop (max.) and highest f-stop (min.). Typically, the lower the f-stop, the more expensive the lens will be. This is because lenses with lower f-stops create more bokeh, are higher in quality and are made with better glass. These types of lenses are very beneficial when shooting in low-light situations because, as mentioned before, the lower the f-stop, the larger the hole in the lens (which then allows more light in).

SEE ALSO

 Manual pp. 26–27

Camera Exposure p. 28

SHUTTER SPEED

Shutter speed is the third and final element that determines exposure. Along with affecting exposure, changing the shutter speed affects the way your camera captures movement.

WHAT IS SHUTTER SPEED?

Shutter speed is the amount of time in which the shutter opens and closes. It is measured in fractions of a second such as 1/60, 1/100, 1/400, but will appear on your display as 60, 100, 400. The longer the shutter is open, the more light is let in and the brighter your image will be. On modern cameras, shutter speeds can range from 1/8000 of a second to 30 seconds.

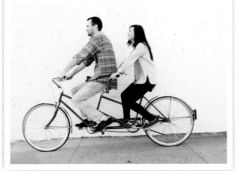

Shutter speed 1/320

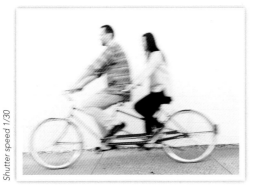

Shutter speed 1/30

WHAT WILL CHANGING THE SHUTTER SPEED DO?

Changing the shutter speed can drastically affect the moving objects in your images in terms of motion and blur. For example, shooting flowing water with a slow shutter speed will produce an image where the water is soft and movement is visible. Shooting the same flowing water with a fast shutter speed will produce a completely different image— the water will be frozen in action rather than smooth in movement. Keep in mind that when changing your shutter speed, you will also have to adjust the ISO or aperture accordingly to obtain an ideal exposure.

SLOW SHUTTER SPEEDS AND TRIPODS

Slower shutter speeds can pick up any slight movement of your hand, causing images to be blurry—this is known as camera shake. A standard rule of thumb is to not handhold the camera if your shutter is set below 1/60 of a second. Although, you should experiment with this, as you may have a steadier or shakier hand.

If shooting with slow shutter speeds is necessary to create a certain image, using a tripod is a good way to avoid camera shake. Tripods also come in handy when shooting in low light when a slower shutter speed is needed.

SEE ALSO

Aperture pp. 30–31

DIY Tripod p. 82

33

CHAPTER 2

WHAT MAKES A GOOD PHOTO?

There are several different elements that make up a good photo. Although what may be considered 'good' is widely subjective, these elements, when considered thoughtfully, can help you achieve better photographic results and also help communicate a desired feel more effectively.

This chapter will cover lighting, white balance, colour and composition, as well as backgrounds and props—basic tips that can help you get a better grasp of photography. Whether you are photographing portraits, events, interiors or landscapes, learning about these elements will be helpful when you're out and about shooting.

Technicalities aside, don't be afraid to get creative, experiment and break the 'rules' to discover what is right for you. This chapter simply offers some recommendations to help get you started.

Lost & Found Photography

NATURAL LIGHT

Using natural light (i.e. sunlight) is one of the easiest and most inexpensive ways to improve your photos. This is because it is so readily available and can help you produce beautiful results. It is helpful to know about different types of natural light, light direction and their qualities for general shooting purposes in indoor and outdoor settings, as the use of light can dramatically affect the final outcome of your images. Natural light works well for most types of photography, including portraits, interiors and food, among others.

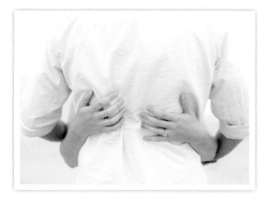

SOFT LIGHT

Soft light is created when a natural light source is diffused, such as by clouds covering sunlight on a bright day or shade created from a tree. This type of light may seem dull, but can be very good for photos, especially portraits, as you don't have to deal with harsh shadows or contrast.

HARD LIGHT

Hard light is light from the sun on a bright day, typically with no clouds in sight. It tends to be harsh, which can be unflattering, especially when taking portraits because it can create very strong contrast and shadows on your subject. Your best bet when faced with hard light is to find softer light in the shade, wait for cloud cover, backlight your subject or go inside and shoot.

FRONTLIGHT

Frontlight is created when the sun is behind you, shining directly onto your subject. Frontlight can appear harsh at certain times of the day, but because it is direct it can help to avoid shadows and unwanted contrast. Similar to backlight, frontlight is most effective earlier or later in the day, as the light tends to be softer. Frontlight is good for lifestyle, travel and landscape photos.

BACKLIGHT

Backlight occurs when the light source is directly behind the subject or object you are photographing. It creates dramatic results with a lot of contrast and may be most ideal to use when you have a softer light, which can be achieved by shooting early or later in the day. Shooting into the sun will often produce sun flares in images, an effect that is sometimes desirable and can add an artistic element to your photos.

SIDELIGHT

Using sidelighting, especially for portraits, can produce beautiful results—and don't be afraid to position your subject accordingly to capture the desired lighting. Exercise your creative eye, as various angles and perspectives can emphasise different textures, moods, emotions and depth in your images.

WHEN TO SHOOT?

Typically, the best time to shoot outdoors is in the morning shortly after sunrise, or in the evening an hour before the sun goes down (also known as the 'golden hour'). This is because light is usually softer during this time compared to the harsh sunlight that often beats down around midday. The colour of light near sunrise and sundown is also typically warmer, a quality that is often sought after.

The downside of natural light is that it cannot be controlled. Shooting in RAW mode is a good idea when lighting conditions may not be ideal. That way, changes dealing with colour and white balance can be made when post-processing.

SEE ALSO

 DSLR pp. 14–15

 White Balance pp. 40–42

ARTIFICIAL LIGHT

Artificial light is any source of light that is not emitted from a natural source such as the sun, moon, stars, etc. Different types of artificial light include flash, external light units, streetlights, light from your fixtures at home . . . basically any light that is created and exists in your surroundings.

WHY USE ARTIFICIAL LIGHT?

Artificial light is necessary when there is not enough natural light to create an image, or when you need maximum control over the lighting. If you take product shots for reviews on your blog, or post before and after DIY images, consistency among multiple photos might be desired, and so control over your lighting conditions can be useful. Using artificial light will give you very different effects to those created by natural light from the sun. Take advantage of the creative freedom that artificial light can offer by constructing different lighting set-ups to see what effects you can achieve.

EXISTING LIGHT

Existing light refers to anything from halogen lighting in a classroom to on-stage lighting at a club or concert, candlelight or stadium lighting at a baseball game. This type of light can be used in photography to create a tone and mood for your images, as it offers a very different look from natural light. It may be less ideal for portraits, as natural light is more flattering, but it can be key to setting a scene and evoking a feeling, especially if you are aiming to preserve the look of artificial light.

CREATED LIGHT

Created light can be controlled more easily than existing light. It is any type of light that is intended to be set off, such as an on-camera or external flash or lighting in a studio. The benefit of this kind of light is that you are in full control of what you produce. You can vary the intensity, direction and colour of the light, and you have the ability to create different results by changing settings. It is also easy to get consistent results with this type of light, as you can replicate light settings from one minute to the next.

WHITE BALANCE

Do you ever wonder why your photos come out yellow or bluish? Or why the colours in your image don't match what you see? Adjusting the white balance (WB) in your camera or while editing is a quick and easy way to improve the overall colour and look of your photos.

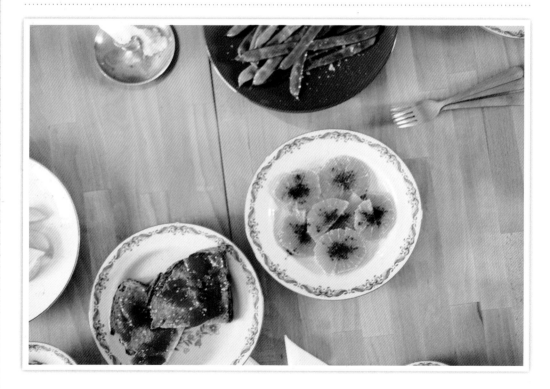

WHAT IS WHITE BALANCE?

White balance is a setting in digital cameras that controls the colour temperature in your photos. Changing the white balance can help you attain true-to-life colours that are consistent with what your eye sees.

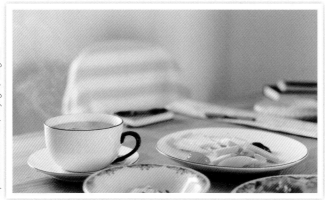

Top to bottom: Auto, Daylight, Tungsten

ATTAINING AN IDEAL WHITE BALANCE

The idea of changing your white balance is to achieve the most accurate colour temperature, making the white areas of your photos appear pure white. There are two ways to change your WB to attain this.

One way is to change the WB setting in your camera before a photo is even taken. Most digital cameras have suggested settings for different lighting and weather conditions. As you can take plenty of test shots without having to worry about wasting film, it can be beneficial to try your camera's multiple WB options when you're shooting in different scenarios, as you may find you prefer the look of one setting to another.

Some photographers like to change the WB after taking the photo and uploading them to a computer. By using photo editing software such as Photoshop or Lightroom, you can adjust the temperature and colour to change the WB of a photo as much or as little as is needed to create the desired effect.

IN-CAMERA WHITE BALANCE SETTINGS

The following are basic white balance settings you will find on most digital cameras:

Auto

The auto WB setting is most commonly used and good for general shooting. With this setting, the camera automatically sets the white balance according to the type of light it senses.

Custom

With the custom setting, you can adjust and set the colour temperature at any time to create your desired white balance.

Daylight

For shooting outdoors in normal daylight when it is sunny. This setting adds warm tones to your images.

Shade

For shooting outdoors in the shade. This setting adds warm tones to your images.

Cloudy

For shooting outdoors when it is overcast or there is cloud cover. This setting also adds warm tones to your images.

Tungsten

For shooting indoors with incandescent lighting. This setting adds cool tones to your images.

Fluorescent

For shooting indoors with fluorescent lighting. This setting adds warm red tones to your images.

Flash

For shooting in low-light conditions with a flash. This setting adds warm tones to your images.

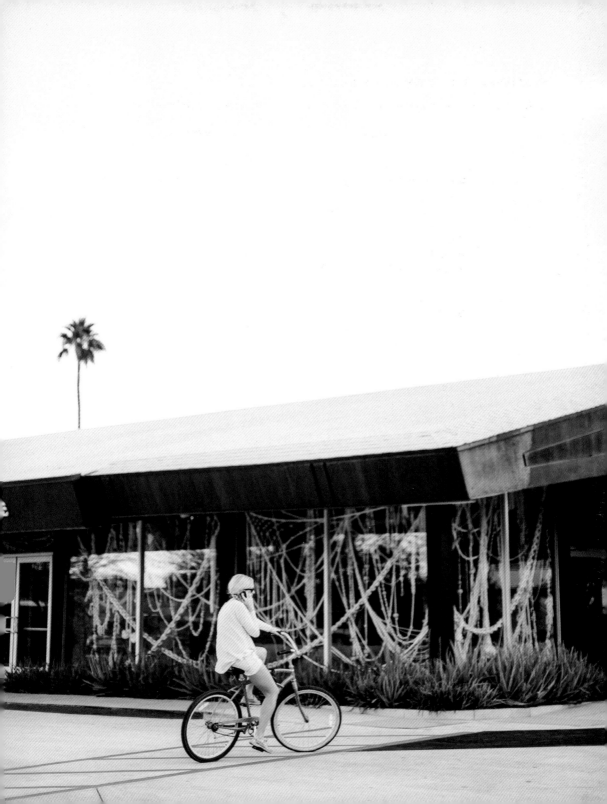

COLOUR

Colour is an essential element in photography that can be used to communicate different moods or feelings. Understanding how colours may or may not work together can help you improve your images and develop a photographic style.

HUE, SATURATION, AND BRIGHTNESS

We think of colour in three different terms: hue, saturation and brightness. Simply put, hue is the descriptive name of a colour (i.e. the sky is *blue*, the grass is *green*, the apple is *red*, etc.).

Saturation is the richness or intensity of a colour. The colours in an image with a lot of saturation will be deep, bright and contrasted.

Brightness is how light or dark a hue is—exposure controls brightness. All three of these elements can be altered in post-processing programs to achieve the results you desire in an image.

COMPLEMENTARY COLOURS

Chances are, you have come across a colour wheel at some point in your life. A colour wheel is a circular illustration of colour hues, divided into segments to show their relationships between each other. Complementary colours on a colour wheel are directly opposite each other. When used together, they can potentially reinforce each other and create contrast. In other words, it can create a 'wow' effect. Using colour can be an integral part in creating a good photo. Many times it is the contrast or harmony of colours that will likely catch one's attention.

Tori Hancock

COLOUR TO EVOKE MOOD

Thinking about colour and how you use it in your images can help you communicate different emotions. Typically, cooler colours such as blue, green and purple will evoke calmer feelings in comparison to warmer colours such as red and orange, which may evoke more intensity and energy. Before taking a photo, think about what you want to communicate and how you can express this using colour. Being aware of your surroundings and using colours to speak in your photos is a skill that can help you achieve more interesting results.

SEE ALSO

 Camera Exposure p. 28

COMPOSITION

Composition—the way you position and arrange your subject as well as the various surrounding details—is another key element of photography. A well-composed photo takes thought and should capture your viewer's attention and inspire imagination. This pique of interest will often lead to curiosity and introspection, which in my book is what a successful photograph does.

There are quite a few traditional 'rules' as to what you can do to create good composition, however, as mentioned previously, experiment and bend or break these rules as you continue to develop your own photographic style and discover what is aesthetically pleasing to your eye.

RULE OF THIRDS

Using the rule of thirds is one of the most well-known basic compositional guidelines. Imagine drawing lines to break up an image into three sections—horizontally and vertically—creating a grid of nine different sections in total, much like a tic-tac-toe board. With these lines in mind while composing your photo, the rule suggests placing your subject on one of the imaginary lines or on one of points where the lines intersect. This creates a more balanced shot, as our eyes tend to be drawn to one of the intersected points.

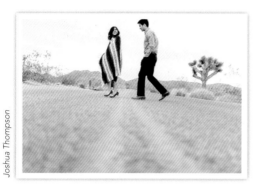

Joshua Thompson

LEADING LINES

Another compositional guideline to capture your viewer's attention is to use leading lines— lines that direct your viewer's eye into the image and to your subject. 'Leading lines' can be anything, from a pathway, to the side of a building, to a fence. Our eyes are naturally drawn to follow lines, which is why using this method can also help create a well-composed photo.

SYMMETRY

Creating symmetry may involve going against the rule of thirds, but can be another compelling compositional technique for creating a good photo. This could involve taking a photo of your subject directly in the centre of your frame or photographing two objects parallel to each other, leaving an equivalent amount of space in between and on either side.

PATTERNS AND SHAPES

Patterns and shapes in images can attract attention, especially if they are unique or recurring. Try photographing your subject against a wall with a funky pattern or using a large circular or rectangular object in your composition, essentially surrounding and framing your subject to draw attention to it.

FRAMING

Framing goes hand-in-hand with composition. Although seemingly synonymous, framing is more about moving your camera around, finding different and unique angles and communicating your point of view or perspective. Once you find a desirable angle to shoot from, then composition (arranging the elements in your frame) comes into play. Framing can also include using elements to give context to a photo. For example, photographing your subject with leaves in the foreground to give the viewer the sense that the picture was taken outdoors in nature.

CREATE A FOCAL POINT

When creating an image, there are many things to think about before hitting the shutter button (unless you are shooting on a whim!). What do you want to include in your image? What do you want to communicate to your viewer, and more importantly, what will be the focal point in your photo? Creating a central point of interest and focusing on what you want to be seen is one way to produce an effective image and capture your viewer's attention.

Ashley Ludaescher

SIMPLICITY

Keeping things simple is my favourite compositional technique for creating moving photos. It is one of the most effective ways to draw a viewer in. You can attain simplicity when shooting by eliminating unwanted or distracting objects in your frame or using bokeh to blur out a busy background.

Michael Young

SEE ALSO

Aperture (for bokeh)
pp. 30–31

SCALE

Scale is used to give perspective, size and depth. Since photos are two-dimensional illustrations of this three-dimensional world, our minds estimate the size of objects by their relationships to different elements in their surroundings. Photos with depth or perspective can be more dramatic and help communicate the third dimension that can be missing in photos. Here are a few tips on using scale to create better photos.

A COMMON OR FAMILIAR OBJECT

A typical way of showing scale is by including familiar and common objects of known size in a photo, such as a car, a coin, a person, etc., to give the viewer a point of reference. This allows the mind to compare and process size, and is especially helpful when photographing something very large.

PARALLEL LINES AND DIMINISHING PERSPECTIVE

Similar to the compositional technique of using 'leading lines', using parallel lines can provide scale and give a photo depth. Railroad tracks, a busy street in the city or rows in a vegetable garden are all examples of parallel lines. Lines help attract attention and lead the eye to see distance. When photographing parallel lines, including the vanishing point (where the lines disappear) in a frame is a good way to give perspective and show scale.

LENS TYPE

The type of lens you use can aid in illustrating scale. Shooting a scene with a wide-angle lens can help create depth and perspective, as objects or elements will appear to be farther apart than if photographed using a telephoto lens. Shooting with a wide-angle lens and including a common or familiar object, as mentioned previously, will give a more dramatic effect and an even stronger sense of depth.

SEE ALSO

DSLR pp. 14–15

Composition pp. 46–49

BACKGROUNDS

The background of an image can be just as important as the subject itself. It can set a scene, tell a story or elevate and enhance your subject and focus point. A poor background can distract and overwhelm your subject or focus point.

COMMON DISTRACTIONS TO AVOID

It can be easy to focus on your subject so much that you forget to pay attention to what's in the background of your photo. Common elements to avoid include lines that may clash or cut through your subject in a distracting way, bright spots or colours that don't complement each other, or random people that divert attention from your subject.

The easiest way to avoid these distractions is just to scan the scene and be aware of your surroundings before taking a photo. Try taking a few pictures and preview them to make sure there aren't any elements that may not fit. Don't be afraid to change angles or move your subject or any distracting objects when shooting.

Caroline Hancox

BLUR OUT THE BACKGROUND

Blurring out the background of a photo by shooting with a low aperture is a simple way to isolate your subject and create a better focal point. Set your aperture to f/2.8 (or lower) to achieve this.

FIND AN EMPTY WALL

Finding an empty wall to use as a background can be especially helpful if you are shooting portraits and want to focus mainly on the subjects you are photographing. If you are shooting against a big wall in an open space, try using a wide-angle lens—this will use scale to create perspective, as your subjects will appear small and the wall behind them vast. Use a shorter length of lens or zoom in for tighter cropped shots to capture details and emotions.

Use feature backgrounds to set a scene and create visual interest for your viewer. Try photographing your subject against a wall of graffiti to reflect a more urban setting, or in an old building with unique and detailed architectural features.

USE OPEN SPACES

Photographing in open spaces, especially outdoors, can help create simple, yet dramatic, results. Often there are less distractions in vast spaces, giving you the option to move your subjects around to shoot wide or close up. To experiment, try angling your camera up so the sky becomes your background canvas, or find a large empty field for simple, yet striking wide shots.

LET YOUR SURROUNDINGS SPEAK

Instead of your background being a distraction, use it to tell a story. How can you convey your surroundings to enhance your subject? This may be photographing your subject in a heavily crowded city, or in a cafe to set the mood.

CREATE YOUR OWN BACKGROUND

Creating your own background is a great way to get the results you want and to have full control over your subject's surroundings. Using plain or patterned fabric (similar to what you can find in photo booths) is just one of many ways to begin creating fun and vibrant backdrops for your subjects. Backgrounds are also great for adding texture, splashes of colour and creative touches to your photos.

KEEP IT SIMPLE

Once again, embrace simplicity. Keeping it simple is one of the most effective ways to create an inspiring image that draws people in. Choose backgrounds that allow your subject to shine or landscape to speak.

SEE ALSO

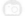 Aperture pp. 30–31

 DIY Seamless Backdrop pp. 78–79

PROPS

Using props can add an element of character and fun to your photos. Often they are used in portrait sessions to personalise images, and they give your subjects something to interact with, which in turn may help ease any 'camera shyness'. Props can range from furniture to food, customised signs, costumes or handmade decor.

Cassie Pyle/Veda House

WHY PROPS?

The goal of using props is to add personality, set a tone and make your photos more interesting. That being said, it is generally best to find props that your subject can use or interact with easily. Common activities that involve everyday 'props' such as riding a bicycle, having a picnic in a park or flying a kite in an empty field can help create more natural-looking, effortless results, and often these objects can be found, or made inexpensively.

When looking for props, think about what you want to communicate to your viewers. What fits best with your subject's style, personality and lifestyle? You don't want props to take away from your subject, but rather enhance and complement them (and perhaps tell a story about them).

STYLING

Another aspect of using props in photo shoots is styling—arranging them in a way that will photograph well and is pleasing to the eye. You can keep things simple and natural, or create an extravaganza of colours and patterns. Styling is one aspect of photography where you can let your imagination shine, so don't be afraid to have fun, take risks and let your creative diva take charge.

Cassie Pyle/Veda House

PROP IDEAS

For portraits Umbrella, hat, glasses, unique chair or furniture, blanket, record player, plants, books.

For kids Balloons, ice cream, favourite toys or stuffed animals, skateboard, bicycle.

Interactive activities with natural props also make for great photos Cooking a meal, playing a musical instrument, reading a book, using a tablet.

DETAILS

Details are a very important part of good photography. Often overlooked, they can make the difference between a good photo and a great one. There are a few things you can do to capture details when taking pictures—some examples include getting in close with your lens, documenting objects of significance or uniqueness and photographing parts of a whole. After your images are taken, post-processing programs give you the opportunity to alter details in a photo.

GET IN CLOSE

Get in close—an easy method to capture details of any kind. Up-close images can pique interest, as they reveal character and are significant for helping give context to a photo (or photo essay). Photograph not only the object as a whole, but also the parts that make it up. For example, instead of shooting a wide shot of a building, move in closer and take pictures of its wall textures. For portraits of kids, photograph their feet in little shoes or small ribbons in their hair. Getting in close means moving in towards your subject, adjusting angles or changing lenses.

OBJECTS OF SIGNIFICANCE OR UNIQUENESS

One aspect of capturing details is to share what is important. Hone in on elements that stand out and are unique. Document objects of significance. These types of details can express feeling and create a deeper sense of connection between your viewer and your subject.

POST-PROCESSING (EDITING)

With recent advancements in technology and post-processing software, it has become easier than ever to transform an image into the photo you desire. Editing can aid in altering details after an image is taken. Photo-editing software such as Adobe Photoshop or Lightroom can be used to crop into an image to focus on details and also add warmth to your photos, adjust colour temperature, remove blemishes or unwanted objects, and much more. However, you should not rely too heavily on the ability to change an image by editing, but rather use it merely as a tool to achieve the desired results you weren't able to capture when the photo was taken.

SEE ALSO

 Editing Essentials pp. 159-161

CHAPTER 3

LEARNING FROM THE PROS

There are many different steps to planning a shoot, whether it is for a blog post or a series of themed shots to upload to social media. How do you come up with an original idea? What if you need more than just your camera? What is the best way to take photos of yourself?

This chapter is all about simple tips to help you pull ideas together, prepare for shoots and take self-portraits, as well as put together a variety of affordable DIY equipment that can take your photography and blog to the next level.

MAKING MOOD BOARDS

Making mood boards is a fun and easy way to share your creative process and style with others. The act of assembling a mood board can be inspiring in itself as you can watch ideas grow and transform over time.

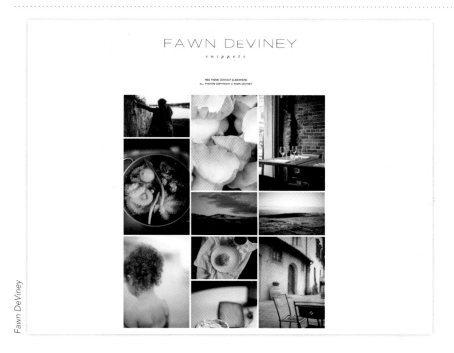

Fawn DeViney

WHAT IS A MOOD BOARD AND WHY ARE THEY HELPFUL?

A mood board is essentially a collage or collection of visual inspirations put together to create a concept to be used for projects such as a photo shoot. They are helpful to collect ideas and communicate a 'mood', direction or feel for a project.

Many designers, photographers, and artists use mood boards to share their vision with their subjects or creative team. Mood boards can also be inspiring to assemble as you can watch ideas grow and transform over time.

DIGITAL MOOD BOARDS

Creating a digital mood board by collecting imagery, fonts, text, etc., from the internet is a quick and easy way to start brainstorming and compiling ideas for a visual storyboard. Organising and assembling your collection of files can easily be done with collage-making software such as Picasa or BlogStomp, or a website like Pinterest.

Pinterest is a popular photo-sharing social media website that allows users to create collections of images with particular themes. You can create mood boards by digitally

'pinning' visuals to a customised page and can 'follow' your favourite pinners and gain followers that enjoy your curated collections. With the option of setting up private boards that are not visible to the public, it can be an ideal platform for creating mood boards for clients or blog projects. With a social media site of almost 70 million users, Pinterest enables you to do word-specific searches for virtually anything posted by other pinners. This makes Pinterest an incredible resource for visual research.

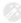

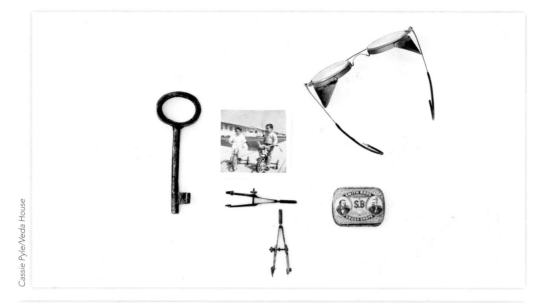

Cassie Pyle/Veda House

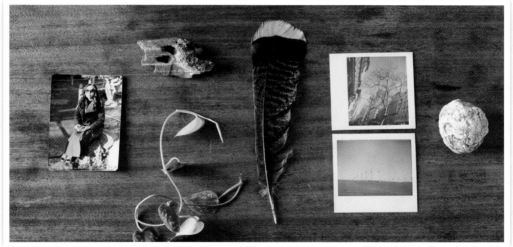

PHYSICAL MOOD BOARDS

The original way to create mood boards before technology became so digitally forward was to use physical objects such as magazine tears, photos, art, etc. A physical mood board can be a highly effective way to show others your concept and ideas, as three-dimensional objects and visual texture may have more of an impact than a digitally created mood board.

TAKING SELF-PORTRAITS

It would be nice if we could have personal photographers with us at all times, but more often than not, this is probably not the case. Depending on the genre of your posts, taking self-portraits, or selfies, may be necessary. Are you fashion focused? Do you need to model products that companies send your way? Do your readers often ask to see more of you?

SELFIES VERSUS SELF-PORTRAITS?

With the increasing availability of easy-to-use high quality camera phones, as well as the prevalence of social media in today's society, selfies are becoming more and more popular. Although self-portraits are great for taking more considered, stylised photos of yourself, seflies are a more fun, playful way of taking your own photos without having to think too seriously about your settings or the perfect pose. They are also a great way of making yourself feel more at ease in front of the camera

USING A TRIPOD AND A REMOTE

One of the easiest ways to set up a self-portrait is to use a tripod, real or makeshift, and a remote (typically used for DSLRs) that fires the shutter. Remotes can be picked up at an electronics shop or online relatively cheaply. Some remote shutters are even available as smartphone apps.

One of the things to take into account when you are setting up a shot is having something to focus on when you are adjusting the camera settings. Whether you are going to be standing in front of a plain backdrop or a background filled with surrounding objects, you will have to focus on something that is the same distance away from the camera as where you will be standing. This could mean setting something in place of you while focusing the lens (before standing in for the shot), or finding an object next to where you will be standing to focus on.

TIMER

If you are working without a remote, the timer setting, which can be found on most digital cameras, is another option. Simply turn the timer on, click the shutter and stand in for your shot. There are typically multiple timer settings that may be helpful for your different needs, such as burst mode (good if you want multiple shots/poses), or an interval timer (which lets you set different amounts of time before the camera takes the picture).

PRACTICE

The best thing you can do to improve your self-portrait skills is to practice. Through trial and error, observe which shots work best for you. Find out what angles are flattering and comfortable, what kind of lighting is ideal and what poses look natural. Knowing these things and being in front of the camera more often will in turn make you a better photographer when you are shooting portraits of other people.

BASIC PHOTOGRAPHY ETIQUETTE

Just like any art in the creative field, there is a basic etiquette in photography. In general, the most important thing is to be respectful when photographing in spaces and places that are not your own.

PHOTOGRAPHING PEOPLE

The etiquette for photographing people in public spaces can be tricky. On one hand, some of the best photos of people are when they are unaware you are taking a picture of them. On the other hand, some people may (and will) get upset if they know that you are photographing them. If you are shooting with a wide-angle lens where many people are in the shot, it typically won't be an issue. I find that the people that get upset are usually concerned with what the photos will be used for. If you desire to photograph people, my advice would be to ask first, then shoot. If you plan to publish these shots, or post them online, make sure you have their permission!

SHARING IMAGES ON YOUR BLOG / CREDITING

Giving credit where credit is due is very important when sharing other people's work—whether it be photography, art, a DIY project or even if you are borrowing an idea from someone else. The same rule as photographing in public spaces applies to sharing other peoples' work. Ask permission from the artist or maker if you want to share their content. Most people will respond in a positive way if you ask kindly, as it is a definite form of flattery!

PHOTOGRAPHING ON PRIVATE PROPERTY (SHOPS, MUSEUMS, HOTELS, ETC.)

If you're interested in taking photos on private property it is always best to first ask an employee if they allow public photography. Most of the time, people will gladly welcome you to take photos of their space and products, especially if it is for marketing purposes such as sharing images on your blog. However, there are places and spaces where photography is strictly prohibited for one reason or another. In museums, there are some galleries that allow public photography and some that don't. Again, it doesn't hurt to ask! Be conscientious and respectful when shooting on private property.

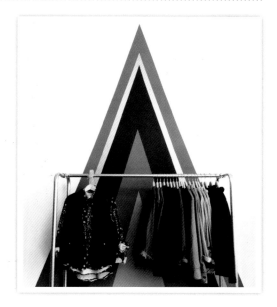

IN-CAMERA TRICKS

'In-camera' tricks can be helpful if you want to add a little flare to your photos using methods other than post-processing (editing) or expensive equipment. This can include experimenting with different settings, manipulating lenses and using filters.

FILTERS

Camera filters are typically any kind of transparent piece of material or an accessory that is put in front of a camera lens to alter incoming light. Filters can add unique effects such as added colours or hues, blur, grain, glow, etc.

Filter accessories that are screwed onto a lens, or off-camera filters, are available online, but can tend to add up in price. The most inexpensive type of filter is utilising a found or everyday object. Common 'filters' include placing a flower in front of the lens, shooting through leaves, a water bottle, coloured glass or even stretching jersey material or tights over your lens. Every slight movement of your found filter will produce one-of-a-kind and unexpected images. Experimenting with these found filters is the best way to see what kind of effects you can get.

FREELENSING

'Freelensing' is a technique that takes quite a bit of practice, but the results can be very gratifying. This method produces dreamy photographs and tilt-shift-like images, which essentially make the objects or subjects in your photos appear miniature. It can also produce photos where only a small part of your image is in focus, and the rest is blurry—it's a really interesting effect when done right. Freelensing requires a DSLR and some people may be more comfortable than others doing this, as it requires the lens to be detached from the camera body.

The process is simple—detach your lens and hold it right in front of your camera's sensor opening (where the lens is usually mounted). Tilt the lens up and down or left and right until focus on a subject is visible. Continue to change the position and tilt of the lens to focus on different subjects. As mentioned before, freelensing can be quite tricky to master, and practice is the best way to help you get good results.

A few tips for freelensing:

- Practice in a wind/dirt-free environment so that dust doesn't make it into your camera's sensor or lens back.
- Hold your lens securely to avoid dropping it by mistake.
- Use a 50mm lens (or greater).
- Set your exposure before detaching your lens.
- On your lens, rotate your focus ring all the way until the distance is set to infinity (∞).
- Set your camera to manual mode.
- If your camera has the option, use live view mode to see exactly what you are shooting and what is in focus.
- Shoot scenes that have a lot of depth, as the tilt-shift effect will be more effective.

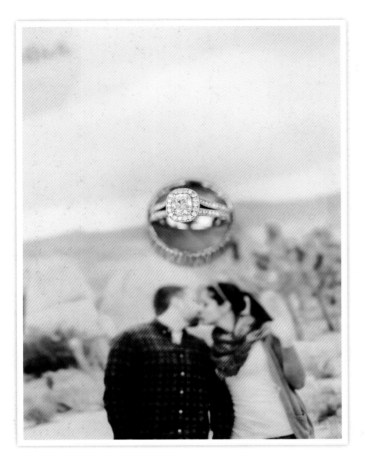

MACRO

If you are not familiar with macro photography, it is essentially taking extremely close-up pictures of small objects. Macro photography exposes details typically not seen by the human eye. Many point-and-shoot cameras have macro capabilities, but DSLRs have actual macro lenses that shoot details incomparable to any other cameras. These lenses can be very expensive, so instead, try experimenting with the options below to accomplish macro images without breaking the bank.

The freelensing technique is also used for macro photography and it is relatively easy to achieve good results:

- Set your camera to manual mode.
- Use a 50mm lens (or greater).
- Hold the camera and detached lens very close to an object and then look through the viewfinder for desired results—depending on your subject, move the lens closer or further away from it to achieve focus.
- Try moving the lens further away from your camera body and refocusing—the further the lens, the more macro effect you will see.

Lens reversal rings:

- These are inexpensive and readily available if you aren't comfortable with the freelensing technique. When attached to your lens, this accessory allows you to connect the front of your lens to your camera body and shoot with the back of the lens, which will also allow you to achieve macro results.

Michael Young

LONG EXPOSURE AND LIGHT TRAILS

Taking long(er) exposures is a simple way to create unique images, especially at night. Using a long exposure means you are allowing light to be received by the camera's sensor for as long as the shutter is open—the longer the shutter is open, the longer the exposure. This method produces images where stationary objects are clearly captured, and any moving elements are blurred. Because a long exposure will pick up any movement or shakiness of the hand, it is necessary to use a tripod.

Exposing a shot for a few seconds (or more) at night will produce light trails, sometimes known as light painting.

DIY CAMERA EQUIPMENT

Photo equipment and accessories beyond your standard camera set-up are sometimes necessary in different spaces, scenarios or lighting situations. Investing in equipment and accessories can add up quickly and cost can become a concern, especially if photography is more of a hobby than a profession. Thankfully, there are many simple do-it-yourself alternatives and substitutions for photo equipment that are inexpensive and can still get the job done well.

Most supplementary equipment you may need in addition to your camera will involve altering light or your flash. Read on to discover a handful of simple DIY projects that will help enhance your photography and also make your photo shoots easier when dealing with challenging light situations.

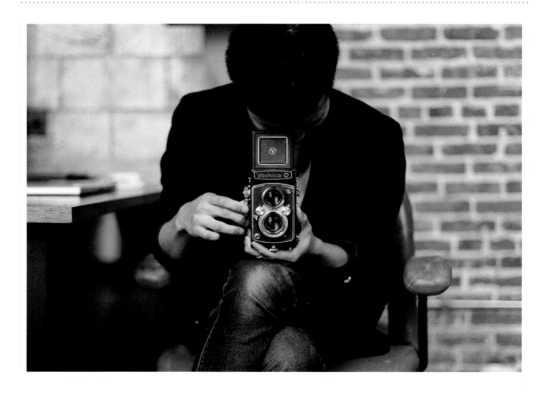

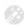

LIGHT REFLECTOR

A reflector can be helpful to control and redirect natural light, and can be especially beneficial for outdoor portraiture. Reflectors come in all shapes and sizes, and the most common colours/types are silver, gold, white and translucent—all interact with light to create different effects.

LIGHT REFLECTOR TYPES AND USES

Using different types of reflectors can aid in creating fill light, lessening harsh shadows and diffusing light. By bouncing light off a reflector, you can control light in various ways.

Silver
Reflects natural white light and brightens the subject while adding contrast.

White
Reflects natural white light, but creates a softer light than a silver reflector.

Gold
Gives your images a warmer tone; good for portraits as it warms skin tones.

Translucent
May be used as a diffuser to block harsh light from your subject.

HOW TO USE A REFLECTOR

Using a reflector may take some practice and experimenting, but for the most part it's very simple! The challenge lies in finding the light and reflecting it in the direction needed.

Place your subject (or object) facing away from the sun and hold the reflector close to them. Allow the light from behind to bounce off the reflector and watch for the illumination created from the reflected light. Move the reflector back and forth until your subject is illuminated.

HOW TO CREATE A DIY SILVER LIGHT REFLECTOR

Creating a light reflector is one of the easiest and most inexpensive ways you can improve your photography.

STEP ONE
Cover one side of the cardboard completely with the reflective material, leaving 2.5-5cm (1-2in) to wrap around the back. If using foil, use the side that is less shiny.

STEP TWO
Turn the board over and tape any excess material down to hold in place.

Plum Jam Photography

MATERIALS NEEDED

- A rigid piece of cardboard (size depends on how small/big you want your reflector to be)

- Tin foil or any reflective type of material

- Tape

STEP 1	STEP 2

TIP

As an alternative, hardware shops sell insulation board panels in different sizes, covered with silver reflective material—an inexpensive mock-reflector perfect for a shoot.

FLASH DIFFUSER

A diffuser is an accessory that can be attached to a camera's flash to spread ('diffuse') the concentrated light it produces to create a softer light.

Diffusers are typically semi-translucent and available in all shapes and sizes. Without a diffuser the flash can produce direct light, which tends to create harsh shadows—this can be particularly unflattering for portraits. When a flash is equipped with a diffuser, the softer light produced is spread more evenly.

There are also flash reflectors, which can help you achieve similar results to a diffuser. However reflectors do not cover the entire light source, but rather they are wider and attached at the top of the flash and extend a few centimetres upwards. This enables light to bounce off the reflector and spread, which in turn produces less direct light.

If you are working with an external flash (one that is not attached to the camera), there is a good chance there will be a built-in diffuser. Diffusers and reflectors are readily available for purchase, but there is also a plethora of do-it-yourself options to create this helpful accessory.

DIFFUSER TIPS FOR BUILT-IN FLASH

One of the easiest and least expensive ways to diffuse light from a built-in flash is to cover the light source with a piece of regular semi-transparent adhesive tape. The tape will act as a diffuser and should help create a softer light.

Another popular option that doesn't require much instruction is to find an old white translucent film canister. Create an opening in the side of the canister just large enough to accommodate your flash mechanism, slide it on to your pop-up flash and you'll have a makeshift diffuser.

HOW TO CREATE A DIY FLASH DIFFUSER FOR YOUR EXTERNAL FLASH

Creating a flash diffuser is one of the easiest and most inexpensive ways to create a softer, more flattering light for portrait photography.

STEP ONE
Use scissors to cut out a piece of the drawer liner around 14 x 39cm (5 1/2 x 15in).

STEP TWO
Cut a strip of Velcro tape to match the width of the liner. Peel one side of the Velcro tape away and place across the top of the liner.

STEP THREE
Flip the liner over to the other side and place the other piece of Velcro on the opposing end.

STEP FOUR
Now it's time to assemble your diffuser on your flash. Hold one end of the liner 2.5-5cm (1-2in) below the top of the flash. Use your other hand and take the opposing end of the liner and flip it down towards the other side of the flash. Wrap the Velcro and secure it around the flash.

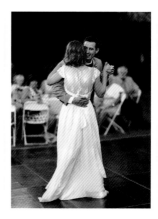

MATERIALS NEEDED

- Transparent non-slip drawer liner or mat
- Scissors
- Velcro tape

TIP

If the diffuser moves around too much, try placing some Velcro on your actual flash (where you want it to stay put) and attach the liner Velcro to it.

SEE ALSO

 DIY Light Box pp. 80–81

STEP 1

STEP 2 & 3

STEP 4

SEAMLESS BACKDROP

A seamless backdrop is a background that goes from vertical to horizontal ground with no discernible transition. They are frequently used in studio settings and can be white, coloured, or patterned. White backdrops are the most popular, as they are ideal for simple portrait and product photography.

Backdrops can be made out of a variety of materials such as muslin, vinyl, canvas, actual seamless paper, or from everyday items such as fabric, butcher paper, or a bedsheet. They are hung on a large frame, which can be quite pricey.

Lovechild Photo

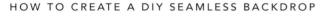

HOW TO CREATE A DIY SEAMLESS BACKDROP

There are many ways to create a seamless backdrop in the comfort of your own home. The first thing that you should decide is what you will be photographing against your backdrop—this will help you determine what scale and size your background needs to be. The following DIY method is inexpensive and works well for product photography.

STEP ONE
Unroll part of the paper or vinyl and attach two sides of it to the wall using the tape or the nails. Try to hang it somewhere where there is a lot of surrounding natural light, as this will make for the best pictures.

STEP TWO
Extend the paper or vinyl down until it reaches the ground and gently roll out the material along the floor.

STEP THREE
Place a weighted object on each side to keep it from moving.

STEP FOUR
Place your object to be photographed on the flat part of the paper or vinyl, so as not to stretch the material or create a seam.

MATERIALS NEEDED

- Roll of white wrapping paper or a roller shade with vinyl from your local hardware shop (other options include a roll of white fabric, a sheet or butcher or seamless paper)

- Strong tape or two nails

- Two objects with some weight

SEE ALSO

DIY Light Box pp. 80–81

STEP 3

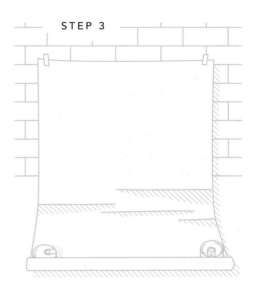

STEP 4

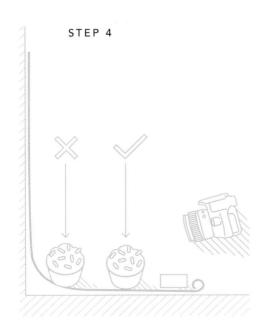

LIGHT BOX

Photographing objects in a light box can make your images look clean and professional. Light boxes are traditionally used for photographing small objects against a plain white seamless background to achieve studio-like results. When used correctly, light is evenly diffused into the box through semi-transparent material, creating a softer, non-direct light.

Lovechild Photo

HOW TO CREATE A DIY LIGHT BOX

A light box can be made with inexpensive materials, some that you may already have in your home.

STEP ONE
Start by taping down the flaps at one end of the box. Then, using the scissors, remove the remaining four flaps at the other end.

STEP TWO
Mark a 5cm (2in) border on three of the four side panels. Cut out the centre of the three panels with the knife, leaving the fourth panel intact.

STEP THREE
Place this fourth side panel face down with the top of the box closest to you. Cut three sheets of the white fabric to fit and cover the three holes (left, top and bottom) that you previously cut out. Tape the fabric into place—the holes should be covered completely.

STEP FOUR
For the backdrop, cut the paper to fit the width of the box—keep the length as it should be long enough to be taped at the top back of the box and extend down and out of the box a few centimeters.

STEP FIVE
This may take some experimenting to get the positioning right, but, depending on what type of lights you have, place or clip them on either side of the box. Turn them on and make sure the light is shining through the fabric, lighting the box up evenly.

MATERIALS NEEDED

- A cardboard box large enough to photograph your subject in

- Scissors and a Stanley knife

- Tape

- A ruler or something with a straight edge for measuring

- White semi-transparent fabric (muslin, organza, nylon, etc.) depending on how much light you want to pass through

- Two standing or clamp lights with daylight bulbs (for white light—not yellow/orange)

- A long piece of white paper or fabric for seamless backdrop

SEE ALSO

 DIY Flash Diffuser
pp. 75–77

 DIY Seamless Backdrop
pp. 78–79

STEP 1

STEP 2

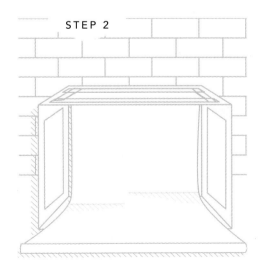

STEP 5

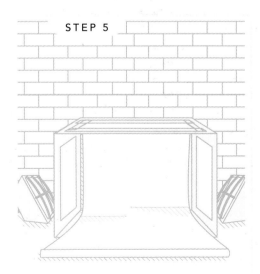

TRIPOD

A tripod is a useful tool for improving results when you want to use slow shutter speeds, are in low-light situations, need sharp images, are taking self-portraits or when you are shooting movement. It supports your camera to avoid camera shake, and is highly adjustable for flexibility when shooting. Tripods range in price, but you can create a makeshift one using materials found in your home.

HOW TO CREATE DIY TRIPODS FROM COMMON HOUSEHOLD MATERIALS

Stable furniture and books Any stable piece of furniture can be used as a tripod. Pull up a table, chair or desk and stack books on it for a desired height and angle. It won't be as flexible as a real tripod, but it will save you money!

String tripod A string tripod is a very simple makeshift tripod for when you need to use a slow shutter speed—great for lower light situations. It won't replace a standard tripod, but it is ideal for a quick fix, or if you are on the go and need to pack light.

STEP 1
Screw the bolt into the tripod socket on the bottom of the camera.

STEP 2
Tie the ends of the string together, then pass the string through the eye bolt and create a loop knot.

STEP 3
Let the string drop to the floor, then place your left foot through the left loop and your right foot through the right loop. Stand shoulder-width apart.

STEP 4
Bring the camera up to create tension on the string, which will then help for a more steady shot. The string may need to be adjusted for correct height.

MATERIALS NEEDED

- Thick cord or string (about three times your height)

- 6mm (¼in) eye bolt

SEE ALSO

Shutter Speed pp. 32-33

STEP 1

STEP 3

SECTION TWO

UNDERSTANDING YOUR SUBJECT

CHAPTER 4

FOOD
TARA O'BRADY

Tara O'Brady authors *Seven Spoons*, an inspiring blog filled with beautiful food photography, delicious recipes, and stories that will draw you in. She lives in Ontario, Canada, with her husband and two sons, and is currently working on her own cookbook.

I enjoy food photography because of the universality of the subject. Not only is food part of our collective and individual histories, it is also very sensual—the experience of taste, texture and aroma is recalled with breathtaking immediacy. A photo can be a powerful communication tool. It is a reaction, on both physical and emotional levels, that makes food such a great topic for blogs.

For me, styling and photographing food is the craft of making viewers not only want to taste the food that's presented, but making them believe they can already.

COMPOSITION AND STYLING CHALLENGES

INTENT

There are many genres of food photography, and you should think about which one suits the purpose of your blog. A journal might be more of an overarching narrative, while recipe blogs may focus on procedure. To portray a mood, you can bring more into the photo—a spoon ready for use, people, more of the room—it is an opportunity to examine how food fits with a larger setting, or place it into a tableau. For instructional pieces, you may want to photograph the individual ingredients as well as the plated meal.

TIMING AND ENVIRONMENT

Even if your food blog has a rigid parameter of focus, say, sandwiches, within that focus there can be a staggering set of particulars from one recipe to the next. With food blogs, it is often the photographer who has prepared, plated and styled the food. Pay attention to the qualities of the dish; during the process, think ahead to how it might be shot. Dishes that are built, such as salads, will often look best from the angle they were constructed.

Most food will show the effects of its environment, so timing can be vital. Anticipating how ice cream will melt or a sauce will thicken can help you address trouble before it happens, or might enable you to react quickly to a changing subject. For example, the appeal of a poached egg is in the particular ooze of its yolk. To that end, when shooting the below image, I grabbed a tripod, placed the food, set the camera to continuous shooting and pierced the egg to expose the yolk. Capturing the weighty drop of yolk also brought movement to the photo, and broke up the dense whiteness of the egg.

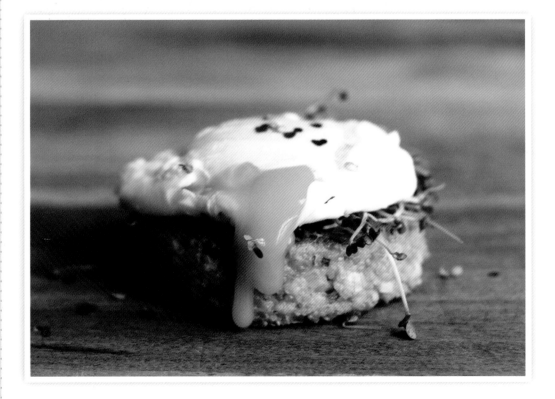

DETAILS

Don't always try to represent a schematic of a recipe. If, say, it's the texture of the pastry that makes a pie exceptional, then concentrate on a corner where the crust has shattered. We see crumbs and immediately recall the sensation of pastry crumbling, and can almost taste the butter. As much as it is necessary to see the artistry in food, it is important to look at the subject greedily, too

In a layered dish, like a parfait or trifle, an overhead shot completely loses what makes it special. Shooting from the side, or pulling out a spoonful instead of concentrating on the whole, showcases the best features of the dish. When photographing this tahini dressing (above right), I specifically chose to show the tahini mid-stir; the suspended seasoning on the

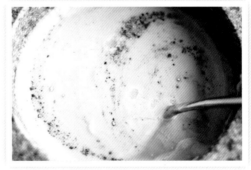

dressing's surface illustrates its viscosity, one of its defining characteristics. Similarly, the crack on top of a quick bread (top) contrasts the crisp crust with the soft interior.

It is often the details that convince the viewer of the worth of a recipe. Make sure to consider the takeaway.

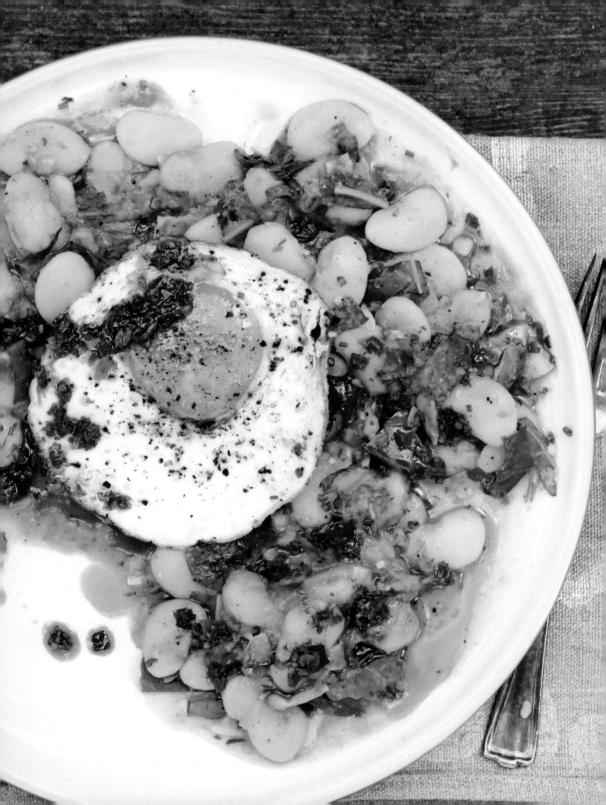

SHAPE

Food is very visual, and recognition of the requirements of shape is vitally important. For example, soup is quite literally flat, and will take the shape of its vessel, making for a boring photo. Use garnishes to add layers and texture to the presentation and make those the focus.

Photographs with strong, singular shapes can be difficult; an unsliced pie, for example, or a loaf of bread. If the subject must remain whole, visually cut the shape through framing. Cropping helps the subject to relate to its background. For sugared buns, photographing a batch arranged in a formal pattern gives the image a strength of geometry. The buns read almost as a single mass, while the slanting light brings an irregularity to break up the strictness of the form and adds surface interest.

A profile view of an iced cake is all solid surface. By playing up the curve of the stand, including the shadow of a horizon line, and catching an irregular stroke of frosting, these fine points interrupt the heaviness of the form.

Tara O'Brady

Blog name
Seven Spoons

URL
www.sevenspoons.net

Camera equipment:
Canon EOS Digital Rebel XS
with a 50mm f/1.8 lens and
Canon EOS 5D Mark II with
a 50mm f/1.4 lens.

Favourite types of shots:
Farm stands and markets,
beautiful produce.

Favourite accessories:
A large piece of white
mat board, left over from
a project. I don't have a
dedicated studio space,
and sometimes my house
can be dim; the simple ability
to bounce light back at a
subject can make all
the difference.

**Favourite photographers/
bloggers:**
For photographers,
Ditte Isager, Jeff Lipsky,
Christopher Hirsheimer
and Marcus Nilsson. For
bloggers, all of whom I also
happen to admire in terms
of photography, Heidi
Swanson, Lecia Phinney
and Molly Wizenberg.

Tell us a little bit about your blogging journey. When did you start blogging and why?
I started my site in May 2005 as both a cooking diary and writing exercise. I wanted to write about food, and my job at the time was far from that, so blogging gave me a way to do so.

Your photos are simply gorgeous! How did you develop your photography skills?
I studied visual arts through high school, but never photography in a practical sense. My older brother was the photographer in our family, even from when we were little, and I was intimidated by his skill. In university, and after, I had jobs that dealt with photography peripherally, but it was only when I started writing about food that I started taking photographs on a regular basis. My style developed through trial and error, and an avid interest in the work of others.

Do you have any favourites when it comes to photo equipment?

Lately, my phone. Keeping a camera almost always on hand encourages active observation. I don't usually photograph for sharing per se, but for the personal practice of seeking out inspiration, framing subjects and creating interesting images.

What kind of advice would you offer someone interested in starting a photo blog?

I don't think there's one way of doing things; if everyone simply followed a set formula, then creativity would never be pushed forward. So, study the basics, experiment. Take a lot of photographs and see what moves you. Get into the habit of reviewing your work; learn to be critical and make notes, even if only mentally. Take every opportunity to learn from peers and mentors. Get comfortable with your instincts. Pay attention, and have some fun while you're at it.

I really enjoy the way you share stories and personal experiences along with your photos and recipes. How has your writing and photo style elevated your blogging career?

I feel it was the other way around. If it wasn't for both the outlet and exposure of the site, I don't know where I'd be. Blogging is what drove me to learn about photography, and is what enabled me to make a career out of writing—it kept me learning and practicing. I found an audience in the process, and opportunities came from there. I am terribly lucky.

CHAPTER 5

KIDS
OANA BEFORT

Oana Befort is a freelance graphic designer and illustrator based in Bucharest, Romania, where she lives with her husband and son. Her eponymous blog showcases her versatile talent through her creative photography, sketches, illustrations, watercolour painting, DIY projects and all-around style.

I have always loved photography and it is a huge part of my blog. My blogging journey started a few months after giving birth to my little boy. I wanted a platform where I could capture the different stages relating to my son and becoming a new mum.

Taking pictures of an always-on-the-run toddler can be quite challenging at times. You can't always create the perfect setting and have your child sit/stand 'that' certain way. One thing I noticed by having my camera always around, is that picture-taking becomes part of everyday life. It becomes a natural thing to do and my little one has become more and more comfortable with the camera.

COMPOSITION AND STYLING CHALLENGES

BE SPONTANEOUS

You don't always have to schedule time to take pictures. Kids always have something to do; they are always 'busy', either playing with their toys, drawing, dancing, eating, flipping through books, etc. Notice those little moments and just have your camera around so that you can snap a few pictures when the time is right. It's that simple—kids don't have to know that they are being photographed. Spontaneous smiles, looks and positions can turn out to be some of the best pictures, and your little one doesn't necessarily have to face the camera.

LET THEM BE NATURAL

There's nothing more special than capturing pictures of your little ones being themselves. Snap a few shots while they interact with their favourite toys, play in the snow, dance to music or simply capture their natural expressions while you tell them something funny. Let them be in a comfortable environment either indoors or outside so you don't have to try so hard to pull out smiles. Timing is also very important— you have a better chance of taking a good photograph of a happy toddler who has just had a nap, than a tired, grumpy one.

FOCUS ON PERSONALITY AND SPECIAL FEATURES

Whether your kids love to paint, make music, play with trains or read books, try capturing their interests and the activities that they love the most. Encourage and praise them for their accomplishments. Kids love it when they are being appreciated and that also helps them relax and be more comfortable in front of the camera. Snap a few pictures of those pretty little curls, those beautiful big eyes or a focused, curious look; capture the love they give through a hug, smiles and things that make them who they are.

BE ON THE MOVE

When you're taking pictures of a toddler running, it's important that you be on the move as well, and try to keep up with their energy level. Try different angles, like taking pictures from above, focusing on their little cute head or using a wider angle to capture the background where your child is running around or exploring. Try to see the world from their perspective by taking pictures at the same eye level as they are, or lower. Seeing your silly positions will also be fun for them.

OPT FOR NATURAL LIGHT

Light is so important. Early mornings or late afternoons are some of the best times for taking pictures, but learning how your camera works and which camera setting you can use in every situation (either inside your home or outdoors) will help you create the right images. If your subject is playing inside a room that has a good source of natural light coming through the window, practice with your camera at different settings, or return at different times of day. Once you get comfortable with your camera settings and light options, things will get a lot easier. You might have to practice a little with different objects and how to position them at different times of the day.

GET CREATIVE

Try using props as a way of telling a story in your pictures, capturing your child's interests. For example, if your little one loves music and dancing, find things like headphones, CDs, etc., to create a cute environment. Plan ahead and create different settings and situations for them to explore, and see what happens. You can also try to start different conversations and just let them do the talking, have them sing, or 'play' an instrument.

BE PATIENT

Sometimes it's hard to get your child's attention when you would like them to look at the camera. While having your camera ready, try to engage them into a conversation where they have to answer a question, or ask them if they want a snack. Sometimes getting a really good picture can be a matter of luck, but practice is really important as well. Don't be afraid to take many pictures, and if things just don't work, try again later. Leave room for imperfections; sometimes even a blurry picture can look pretty.

NOTICE THE LITTLE DETAILS

Try snapping pictures of drawings your child is making, pencils they are using, their little toes covered with sand, their first teeth, their favourite toys, their favourite food or painted hands. All these little details gathered together make such a beautiful collection of memories to look at when they are grown up.

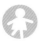 # *Oana Befort*

Blog name
Oana Befort

URL
www.oanabefort.com

Camera equipment:
Nikon D7000. My all-time favourite lens is the manual focusing Nikon 50mm f/1.2 AI-S.

Favourite types of shots:
I love shooting using a lot of natural light, especially in early mornings or late afternoons. I prefer the outdoors while taking pictures of my little one and I love when my working table has natural light surrounding my artworks and art supplies.

Favourite accessories:
Tripod and camera remote control (but only in the situations that are required).

Favourite photographers/ bloggers:
Olivia Rae James and Elizabeth Evelyn of *Local Milk.*

Tell us a little bit about your blogging journey. When did you start blogging and why?
I started my blog at the end of 2010, a few months after becoming a new mum. I did it because I wanted to discipline myself. I wanted to continue being creative and inspired while raising a child. I also created the blog to document bits and pieces of our daily life and to keep in touch with far away friends and family.

Not only are you an amazing photographer, but an incredible illustrator and designer. Did you go to school for any of these artistic endeavours or are you self-taught?
I studied fine arts in high school, then I went to college to study graphic design and got a Masters degree in Graphic Design and Visual Communication. I have always loved photography and I have studied it and experimented with it as a hobby, and as a way to promote my work and capture moments of my personal life.

What is your favourite social media outlet and how has it benefited you?

My favourite social media outlet is Instagram. It's so easy to use. I have promoted a lot of my work through it, made new friendships with other creatives and also gained a few clients.

Do you have a favourite when it comes to photography equipment? What is ideal for photographing a child on the move?

Basically, using any DSLR camera these days can help you take good pictures, but the key is to learn how to use it. Depending on what kind of quality you need or how you would like to use the picture, you can even get a good moving image with your iPhone.

What would be your top three tips for posting content that draws people in?

My top three tips would be:
1. Be honest.
2. Share the things that represent yourself and make you special.
3. Try to be consistent in what and when you post.

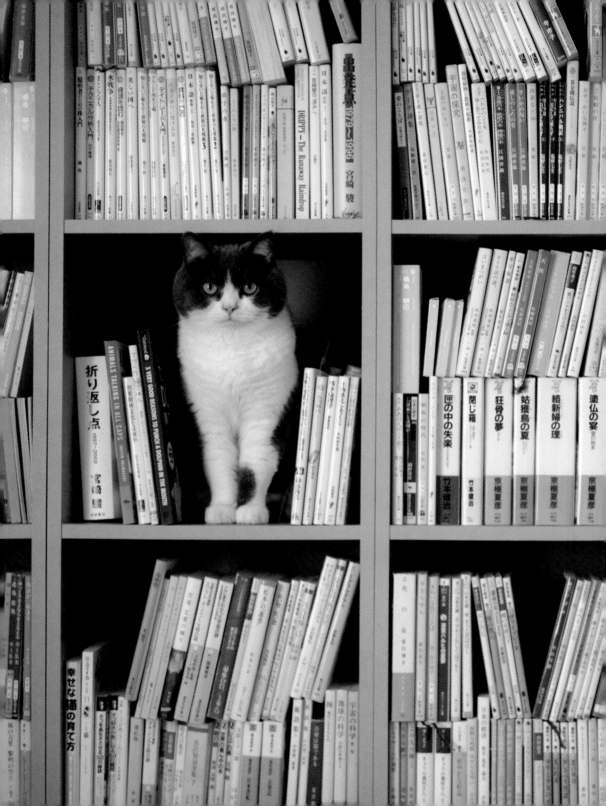

CHAPTER 6

PETS
GUREMIKE

Since 2008, the creator of *guremike* has been taking photos of the blog's stars—two Scottish Fold cats—to share with the world. While beautifully shot and composed, guremike's photos always maintain a playful edge. guremike and the cats live in Japan.

I think over the years I have taken several hundred thousand photos of my cats, and I have to say, I never get tired of it; they are always doing something different, surprising me a nd making me smile. I try to keep my photos simple and natural, to allow the focus to stay on the cats and their unique personalities.

COMPOSITION AND
STYLING CHALLENGES

SPONTANEITY

Believe it or not, all the photographs I take of my cats are spontaneous. Nothing is posed. I think the key to taking good pictures of pets is to create a comfortable living environment and a steady routine. To do so I have built a good relationship with my cats, and keep a well-balanced daily life. I don't do anything particularly special, I just observe their movements carefully, every day.

I spend a lot of time waiting for an ideal situation, which requires huge perseverance! I have a camera in every room to prevent a photo opportunity being missed. I even have three of the same camera!

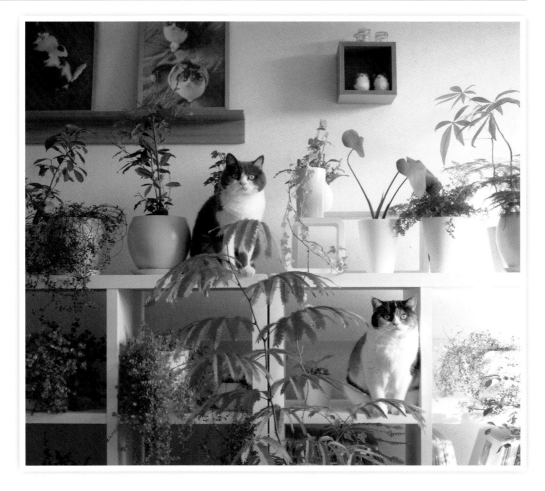

PATIENCE

Patience is key. For example, I spent at least two hours trying to get the image of my cats in the bookcase (shown on p. 107). I know my cats like playing in the shelves, so I made a narrow space big enough for a cat in parts of the bookcase on purpose. Then I waited, and waited and waited . . . persistently and stealthily!

When the cats were in position, I took around 200 to 300 shots. I shot in aperture priority mode, and once I had chosen the best image. I enhanced the brightness and adjusted the contrast in Adobe Photoshop.

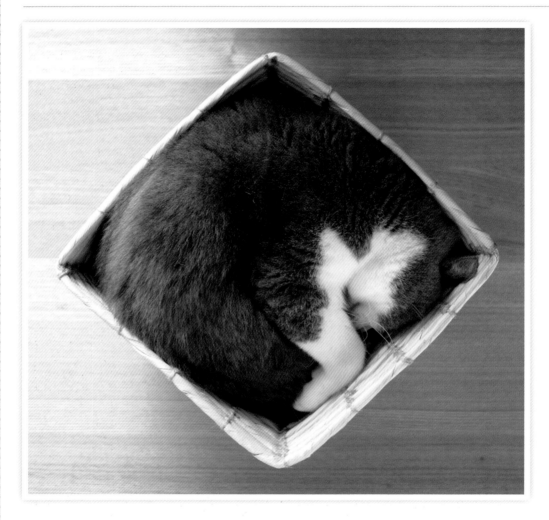

NATURAL COLOUR

Generally, I prefer to use the low vividness and low contrast colour settings on my camera, because I think it's much closer to what's seen through the eye. I aim to keep colours as natural as possible. Most recent digital cameras are geared to produce colours that are too bright and showy for me. They might be very beautiful and brilliant colours, but I think it's just not lifelike. I aim to take soft, natural, and simple colour photos.

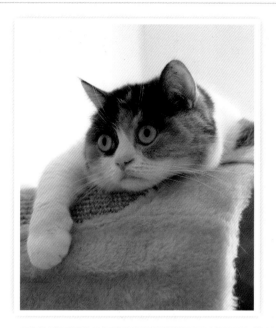

CAPTURING LIGHT

Natural light is good for pet portraiture—it helps capture detail, such as beautifully delicate fur and eyes that shine like jewellery. I try to take pictures during the daytime and use as much natural light as possible. Unfortunately, my cats are most active at night . . .

I use a fixed focal length lens with a large aperture to capture as much light as possible. The downside of using this lens is that I'm not able to zoom, so I have to get closer to the cats when shooting. However, I think this actually helps make my photography unique and dynamic.

SYMMETRY AND COMPOSITION

I like symmetry in photos. It has a big visual impact. Symmetry is appealing and it attracts people's attention. It's also an important feature of my photo blog. I often use the grid lines in the camera as guidelines. I choose an angle and frame the photo to direct people's attention to the candid expressions of my cats.

 # *guremike*

Blog name
guremike

URL
guremike.jp

Camera equipment:
RICOH GXR with A12 50mm,
A12 28mm, A16 24–85mm
and RICOH GR.

Favourite types of shots:
I like simple, natural and
easy-to-understand shots
and settings. I use a fixed
focal length lens to get as
much brightness as possible.

Favourite accessories:
I sometimes use a tripod,
but I don't use any filters or
other accessories.

**Favourite photographer/
blogger:**
I love too many to choose!

**Where did you learn photography and how long have you been
taking pictures?**
I learned the craft of photography on my own. My father likes
photography and has been taking pictures since before I was born,
so I grew up surrounded by photos and cameras, which has had a big
influence on me. I have been taking pictures for about ten years now.
I make new discoveries every time I train a camera on my cats.

Do you have a favourite camera to use?
I really like RICOH cameras, they are lovely. Currently I use the
RICOH GXR and GR.

How do you capture such amazing pictures of your cats in interesting places and spaces?
The setting for my photographs is essentially my whole house, and so I always need to keep the house clean! Around my house are boxes, foxtail toys and balls of wool, among other things, which the cats like to play with. Mainly I just take an extreme amount of photos every day. The more pictures I take, the more I learn.

What are a few tips you would give to people who are just getting into pet photography?
Watch your pet's behaviour and habits very closely every day, and take a surplus of pictures. I don't think you need to have an expensive camera, the most important thing is to enjoy yourself!

What has been the biggest challenge you've run into when photographing your pets?
The biggest challenge has been capturing images that are not rough, blurred or out of focus. It looks easy, but it's actually very difficult! Also, I try to keep my blog and photography simple, so that it's something that everyone around the world will be able to understand easily, even if their languages and customs are different.

CHAPTER 7

INTERIORS
AND HOMES
DABITO

Dabito runs *Old Brand New*, a well-known lifestyle photography blog with a focus on interiors, DIYs, music, art and design. His photography displays his versatile talent, refined eye and tasteful style. Dabito lives in Los Angeles, California.

I enjoy photographing fleeting moments and interiors with film and digital for *Old Brand New*. The photos I like to create for my blog are typically mundane moments. I love capturing the quiet, day-to-day moments of people and their surroundings, and the objects they touch. It's like the objects have a life of their own.

COMPOSITION AND
STYLING CHALLENGES

VIGNETTES

Vignettes are great ways to showcase how a space is used. They tell a story, create a dialogue between objects and give some details about who's living in that space. Start with a bedside table, bench, mantel, console or dresser—almost any flat surface will do. Gradually add items such as your favourite tchotchkes, a lamp, some plants or flowers, a radio, books or art. Create varying levels of height by grouping objects together in twos or threes. You can also stack things on top of each other.

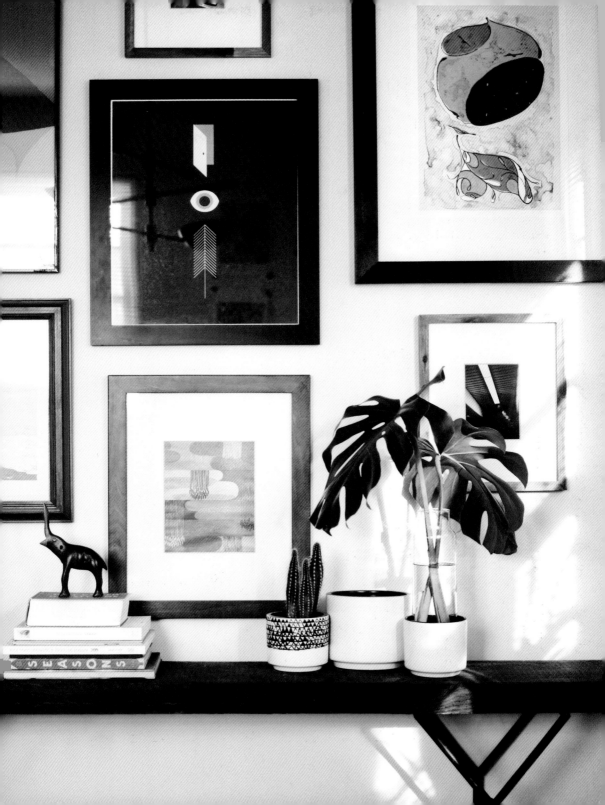

ABSTRACT

A great way to mix up the way you photograph an interior is to train your eyes to see certain corners of a space in a more abstract way. Find colours, patterns, shapes and lines, and see how they all interact with each other. Get close and photograph a tight shot. Other ways to shoot differently is to get on a chair or a bench. Look down onto a table. Or get lower, even lying on the floor, and photograph the architecture of the space. Try tilting your camera just ever so slightly to add interest to the photograph. Don't worry too much about horizontal and vertical lines; this is an opportunity to be a little more whimsical and adventurous with your photography. Play with the negative space and the camera's depth of field. Blurring on purpose can give a dreamlike quality to your photos. You'll end up with interesting shots that'll make an interior look more magical.

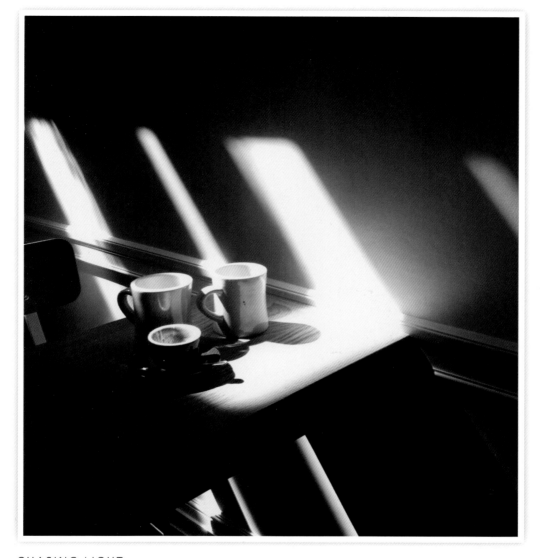

CHASING LIGHT

Natural light is best for interiors. To add more drama to a space, try to photograph in the afternoon. If you want to create a moody feeling within a space, play with lightness and darkness. See how the light shines through the windows—if there are roman blinds, control how much light you want to let in and see how the light paints the space and the walls. It indubitably makes the room look more real, animated and intimate.

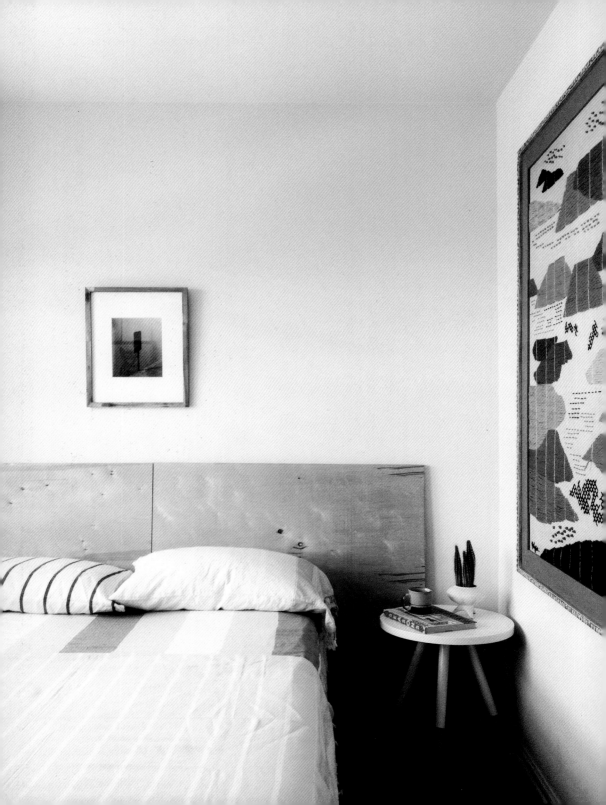

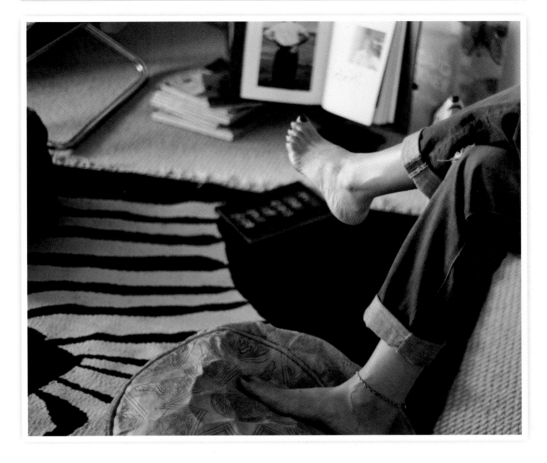

STYLING

When it comes to styling, it's all about making a space look lived in. Add a mug or glass to a table with an opened book or magazine to make it feel like there's a bit of a human touch. Make it look natural without over-styling. Your styling will depend on the home. Sometimes a beautiful mess may be what you're after, other times it could be something super-minimal. I also recommend photographing the person living in their home, as it adds context to the space. Have him or her prepare something, such as putting flowers in a vase, arranging books or fixing some snacks. You can also photograph just parts of their body and how they interact with the space, such as a person's arms on a couch touching a pillow. Photographing people in their homes activates the space.

Dabito

Blog name
Old Brand New

URL
www.oldbrandnewblog.com

Camera equipment:
Yashica Mat, Yashica T4,
Contax T2, iPhone 5s,
Canon Digital Rebel xTi

Favourite types of shots:
I love mundane moments,
especially featuring a person
in a beautiful interior.

Favourite accessories:
My most used accessory
when photographing
interiors is my tripod.
They really become your
camera's best friend.

**Favourite photographer/
blogger:**
One of my favourite
photographers is Daido
Moriyama. I love how he
captures fleeting moments
with such rawness. My
favourite blogger is Justina
Blakeney. She is truly an
inspirational woman with
such a strong point of view.

**Tell us about the beginnings of how *Old Brand New* came about.
Why did you start blogging?**
Old Brand New began as a creative outlet for me. I'm an artist
so I enjoy dabbling in many creative mediums, like printmaking,
photography and graphic design. I also wanted to document my
daily finds from thrift stores and flea markets. I love decorating
on a budget and I wanted to inspire other people to do the same.
You don't have to break the bank to make a bold statement in
your home.

How important do you think image quality is to blogs?
I'd say it's very important, especially for lifestyle blogs, which rely
heavily on photographs, whether their focus is on food, interiors
or daily adventures. It's a visual voice that anchors your blog.
Writing is important too, but if you're not the best writer, photos
can speak for you.

You have quite the collection of cameras! What is your favourite piece of equipment to use?
I keep finding them in thrift stores and I can't peel myself away from rescuing these extinct treasures. Many of them still work and I love experimenting with them. My favourite right now is definitely the Yashica Mat.

What advice do you have on interacting with social media and creating an online presence and community?
The online community is extremely supportive. It's a great platform to explore, experiment and expose your work and business. It's easy to start up a dialogue with other bloggers on Instagram or Twitter and get feedback. It's super easy and it's a good way to exchange ideas or collaborate. I think, in general, good advice would be to have fun and be yourself.

Your aesthetic is very recognisable, and one that many people are drawn to. How did you discover and develop your style?
I discovered it when I was studying print-making and photography in college. I was very inspired by Nan Goldin and Edward Hopper. I want my photos to exude an emotion. And sometimes that can be achieved by the subject matter, and sometimes it's the way you develop your photos. Train your eyes to see what you want to see. It could be colour, shapes or movements. It's all there for you to capture. Just take a lot of photos.

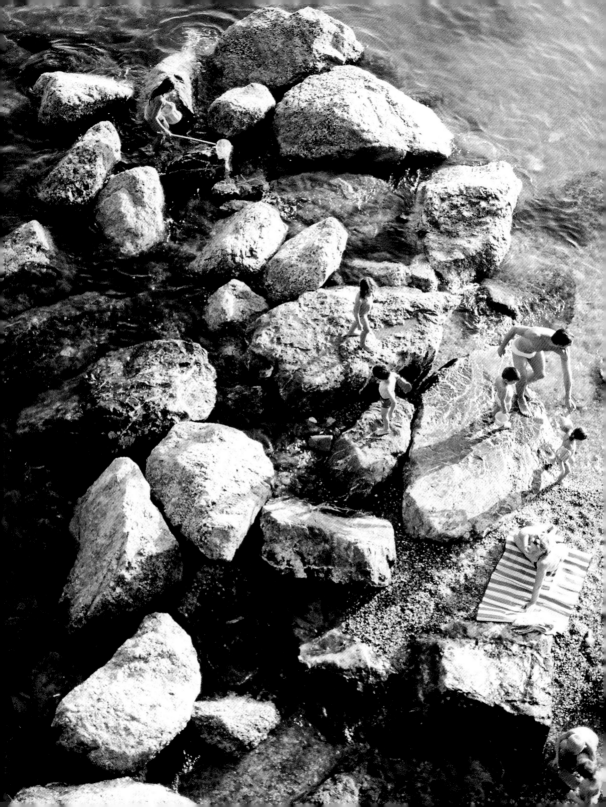

CHAPTER 8

TRAVEL
LEILA PETERSON

Leila Peterson's self-titled lifestyle and travel photography blog has the ability to give any reader a serious case of wanderlust. When not on the go, Leila can be found in London with her husband and French bulldog, Beta.

Weeks of planning, travel itineraries, delayed trains and cancelled flights. Seeing a city for the first time, and feeling its thick air close against your skin as you step out of the plane and onto the tarmac. The excitement of somewhere new, a foreign culture, roaming the streets and tasting the food. These are just a few of the things I love about travelling. Throughout the years, I've found that my best travel stories, and in turn, travel photography, came when I was open to trying new things, and when I embraced the culture and challenges that come with being in a foreign country or city.

COMPOSITION AND STYLING CHALLENGES

DETAILS

Pay attention to the little details. After shooting a wide shot, such as a landscape, move in closer and capture the details around the area, like this bougainvillea I shot in Italy. I spent some time shooting the town from up on the hill, but then noticed the brightly coloured flowers lining the path. I took a few tightly cropped shots and framed some islands in the distance. I tend to shoot these photos with my aperture wide open, around f/1.4-f/5.6, to get a good depth of field.

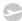

POINT OF VIEW

Shoot from different angles. Try holding your camera high above a crowd, or lie down and shoot upwards. Climb to the top of a mountain, like I did here, or a building, and shoot a busy scene below. These can all add a different perspective to your photos.

LINES

Be conscious of not only horizon lines, but windows, doorways and buildings. Try to keep lines at zero degrees. It's amazing how much better a photo looks on your blog when the horizon line is straight. In this photo of a train station in Switzerland, I made sure the trains, train tracks, escalator rails and poles were all balanced and even before taking the photo. Getting the photo right in-camera will save you a lot of time in post-production.

CONNECTING IMAGES

Connect your images to create a story. Cull your photos and make sure you have a good variety of shooting styles included, like landscapes, portraits, street scenes, food and movement. When creating your blog post, and adding your photos, move your images around until you're happy with how each photo looks next to one another. I like to play with colour when putting together a blog post. The pastels in the ice cream photo go perfectly with the sky in the photo below.

PLANNING

Research everything beforehand. Check sunrise and sunset times, then get up early or shoot right before sunset, while the light is soft and lacking harsh shadows. Read travel message boards and comments on travel blogs. Search the name of the city you're visiting and its hashtags on Instagram. Look at maps and Google unknown towns around the area you're travelling to. Take note of what stands out to you the most and plan your journey around all of the information you've gathered.

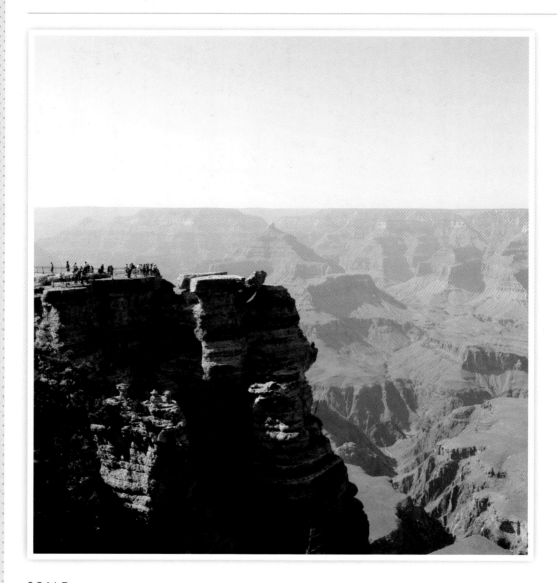

SCALE

Including an object or person in a landscape photo adds a sense of scale. For example, when shooting a photo of a mountain range, search for people or objects to add into your frame. This allows your viewers to get an idea of how dramatic the landscape looks in person. I shot this at the Grand Canyon, after seeing a group of people walk out to the edge of the cliff.

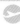

SUBJECTS

Taking portraits or environmental portraits adds a personal touch to your travel story and creates a balance between your landscape and detail photographs. People go about photographing strangers in different ways. Some ask permission, while others shoot and leave. Either way you go about doing this, always remember to be respectful.

Leila Peterson

Blog name
Leila Peterson

URL
www.leilapeterson.com/blog

Camera equipment:
Contax 645, Contax T3,
Canon 5D MK II with 35mm
f/1.4 lens, Polaroid 180,
Polaroid SX-70 and Rolleiflex
E 80mm f/2.8.

Favourite types of shots:
Generally, landscapes and
documentary. The desert,
the ocean and views from
way up.

Favourite accessories:
A tripod for my digital and
film cameras, and an iPhone
tripod for long exposures.

Favourite photographers:
Vivian Maier, Joel
Meyerowitz, Eugène Atget.

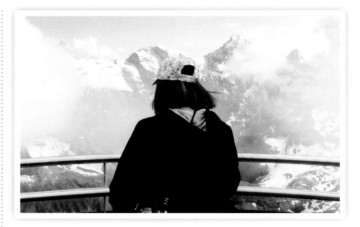

Tell us a little bit about your creative journey. Did photography or blogging come first for you?

Photography came first. I grew up with my parents documenting everything from school talent shows and family vacations to slumber parties and new pets. My dad mostly used an SX-70 Polaroid camera that he later passed on to me—I still use it to this day, and it's one of my favourite cameras. Later on in high school I took darkroom photography and fell in love with documenting moments. I couldn't stop taking photos of everything that was happening around me. It was also a way for me to express myself, since I'm naturally really quiet and shy around people. My husband and I moved from Honolulu, Hawaii, to Los Angeles, California, in 2008, which is when I started my wedding photography business. I started blogging at the same time so that my friends and family back home could follow along with my new life. I ended up meeting a lot of really amazing people along the way!

Can you give us three tips of advice for photographing new places when travelling?

1. The most important thing for me when travelling to somewhere new is to gather as much information as possible before the trip. I search for images and places I find intriguing and write down ideas for photos I want to take, bookmark restaurants and research activities to do beforehand.

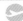
2. I like to be patient when taking photos in a new country or city. I find a background that catches my attention and wait for elements to come together in my frame. It not only helps me get interesting shots, it allows me to sit down in one spot and relax. Sometimes as photographers we're always running around looking for photos, so it's good to relax a little and take in the new sights, sounds and smells.

3. Have fun. Put your camera down. Breathe a little. It's amazing what you'll be able to see when you're not looking for something.

What are your go-to cameras when you're on the move?
I take my Contax T3 with me everywhere because it's so convenient and sharp. Additionally my Contax 645 medium-format camera, Canon 5D MK II, Polaroid 180 Land Camera and iPhone.

Do you have a favourite social media outlet, and if so, how has it helped you create a readership for your blog?
Instagram would definitely be my favourite outlet, it's changed the way I see things and view the world. I've also met a lot of really talented, amazing people through it. Most of the people I've met on Instagram also blog, so there's somewhat of a link between the two.

Your photos are so moving and exude a calmness. How do you achieve this and is it something you consciously think about when taking photos?
I try not to think so much. I tend to overthink sometimes and it results in shots that look a bit staged, or unnatural. When I'm visiting a beautiful place, or if I feel a connection to something, I'll try to find a way to translate that feeling or mood into the photo in some way.

CHAPTER 9

FASHION
MICHELLE LAU

Based in Perth, Australia, Michelle Lau is a fashion and lifestyle blogger with sensible style and a keen eye for beauty. She is frequently on the go looking chic, and she loves travelling and photographing her steps along the way. Michelle's work can be seen on her blog, *A Minute Away From Snowing*.

Fashion blogs have become a dream-world unto themselves. What separates the good from the great is beautiful imagery. What's important is the story you are telling through the looking glass. Inspiring fashion photography encompasses clear, creative direction and conveys a unique point of view. Images that let people escape to another world leave positive and lasting impressions.

Blogging about fashion is fun, but it can be challenging! As a fashion blogger, you wear many different hats—and all at once. You're a creative director, a stylist, a hair and make-up artist and the model. And if you're shooting with a self-timer and a tripod, you're the photographer, too!

COMPOSITION AND STYLING CHALLENGES

LOCATION, LOCATION, LOCATION

Scouting for the 'right' backdrop for your outfit is just as pivotal as pulling together a Sartorialist-worthy ensemble.

During a recent vacation to Venice, I took the opportunity to use the vivid facades along the canals as a backdrop. Venice is incredibly nostalgic and character-laden, so I chose a relatively uncomplicated outfit that would complement the city's romantic sensibilities.

On the other hand, a blank canvas can also have enormous impact. I find gray or white walls

(with paths that are free from rubbish and the like) work best, resulting in a very clean and streamlined aesthetic.

Often, the location can make or break your photos, even if you happen to be carrying the most coveted handbag in the world. By the same token, a spectacular and carefully considered location can elevate the simplest outfit from plain to phenomenal.

GOLDEN HOUR

As any person who takes photos regularly will tell you, the best time to photograph is about an hour or so before sunset. Often referred to as the 'golden hour', the soft glow of light that is often accompanied by fairy floss skies invariably makes for some amazing photographs, without even trying.

I tend to avoid shooting in the middle of the day when the sun is at its highest and brightest. Waiting until the sepia-toned afternoon to photograph brings out the subtle details in my outfits, enhances the background, eliminates any harsh shadows and makes my complexion glow.

I also rarely use a flash when photographing my outfits, preferring natural light. The result is soft, beautiful photos that can often turn the most ordinary of locations into something straight out of a magazine editorial.

TELL A STORY

Telling a story through your fashion photos can mean the difference between average and awe-inspiring.

Sitting serenely on a park chair in the middle of a deserted Jardin des Tuileries, with nothing but an empty seat next to me, suggests that I've been exploring Paris gloriously and languidly, briefly stopping to take in the wondrous sights before me. The photo takes viewers halfway across the world to a place they'd rather be and a solitary moment they might hope to recreate for themselves sometime soon.

Similarly, carrying a bouquet of flowers and sporting an averted gaze suggests that I've just taken a leisurely trip to my local farmers' market as part of my Saturday morning flower run. I'm a momentary picture of calm—and I'm taking you, my reader, blissfully along for the excursion.

Whether I'm photographing in my neighborhood or on vacation in Paris, the brief is always the same: create an air of mystery and ambience that evokes the imagination and senses of the viewer.

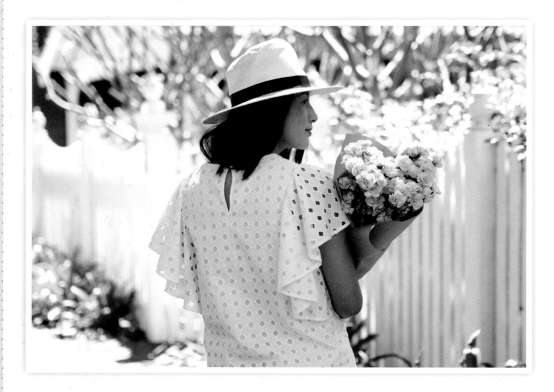

THE DEVIL'S IN THE DETAILS

Whether you're using a tripod or a friend to take close-up shots of your shoes, accessories or cat-like eye liner, the secret to photographing your outfit in more detail is all in the angles.

Imagine dividing yourself up in thirds from head to toe. If you want to photograph the middle third (an example of this is above), have your photographer bend at the knees so that the camera is chest height. Every detail counts with these photos—the placement of your hands, the zipper on your handbag or any loose threads. A fresh manicure also goes a long way!

Photographing the bottom third (such as shoes) can be trickier. The most flattering photos are taken as close to the ground as possible with the camera lens pointing ever so slightly down.

Detail photos add depth and dimension to your posts, casting a wide net for your readers to see your outfit in more ways than one.

GET MOVING!

Incorporating movement in your photos can be a fabulous way to tell a story or create some drama.

Movement shots make a refreshing change to static ones (those which have you standing in the one spot with you in poses that invariably look the same). They're a great way to showcase more of your location, particularly if you're travelling.

The key to achieving movement shots in the most natural, uncontrived manner is to have your photographer take plenty of them. In my photo below with the balloon, I walked back and forth from one end to another about half a dozen times.

The most important thing for me was to have as many photos as possible to choose from so that I could pick the one where I looked the most relaxed and spontaneous.

Think about elements of movement such as the way the wind makes your skirt or dress flutter, a shot of you crossing the street (pedestrian crossings are great for this) or simply your hair throwing caution to the wind—these are the kind of things that are great to capture in your photos.

Michelle Lau

Blog name
A Minute Away From Snowing

URL
aminuteawayfromsnowing.com

Camera equipment
Nikon D600 DSLR with Nikkor AF 50mm f/1.4D lens, Olympus OM-D E-M5 with M.Zuiko Digital 45mm f/1.8 Telephoto Prime lens.

Favorite type of shots:
Candid, photojournalistic shots that perfectly capture a moment in time—with a smile.

Favorite accessories:
I'm a devotee to Crumpler camera gear—I use the Million Dollar Home bag, a camera strap, and the Haven Pouch.

Favorite photographer/ blogger:
New York photographer, Alica Gao. I love how she sees extraordinary beauty in ordinary things. In terms of bloggers, it has to be Nicole Warne from *Gary Pepper*.

Tell us how you came about starting your blog.
A Minute Away From Snowing started as a fluffy, superficial, peripheral escape from the 9-5 daily grind. It's a passion project that brings together my love for fashion, lifestyle, and travel—but first and foremost, writing and photography. It has opened up more doors for me than I could have ever imagined.

What are your top three tips for taking amazing self-portraits?
1. Finding the right light is crucial. If you're outdoors, try shooting in the afternoon where the setting sun can make for beautifully ambient photography. If you're taking portraits indoors, find a place next to a window (ideally lined with curtains) on a sunny day. Naturally diffused light streaming through the window will cast fewer shadows on your face, making your skin appear flawless and even-toned.
2. Camera angle. Tilt the camera lens head-on or slightly downward for a more flattering result. Be mindful not to point the camera down too sharply—it can look unnatural and dated. I also try to avoid having the camera lens too low; double chins are not a flattering look either!
3. Have personality. Technical tips aside, what can really make or break self-portraits are the subjects themselves. Keep your expressions relaxed and playful, try averting your gaze away from the camera for a moment, and don't take it too seriously. Have confidence—remember, the camera never lies!

What is your advice for picking out flattering outfits that photograph well?

The most important thing is to feel 100 percent comfortable with what you're wearing. Wearing something new or an outfit you've never thought to wear before will always put a pep in your step and it's this confidence that will really photograph fabulously. Secondly, some colours photograph better than others. It's notoriously difficult to photograph black (even worse if you're wearing black head to toe), but if you can't avoid it, break up the monotony by pairing together different textures. A brightly coloured shoe or handbag will also make the world of difference.

What is your favourite equipment or accessory to use?

My Olympus OM-D E-M5 is my secret weapon. Not quite a compact, but not quite a DSLR, it's lightweight, can hold its own reasonably well in low light and it has an appealing retro-style look to it, too. I also love toting around my Fujifilm Instax Mini camera when travelling—nothing beats film to create those nostalgic snapshots to remember your travels by.

How do you know where to shoot when travelling in new places? Are there certain kinds of backgrounds that you are drawn to and look for?

I fly by the seat of my pants most of the time! I've recently travelled to places like Iceland, Paris, Cinque Terre and Lake Garda, so a beautiful serenity nook was never too far away. I am drawn to certain things when I have a camera in my hand though: fresh flower stalls on a path, the ombre blues of an ocean and old, vintage bikes and Vespas. They always make for really great photographs.

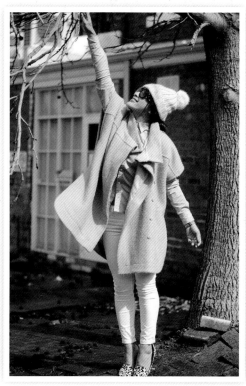

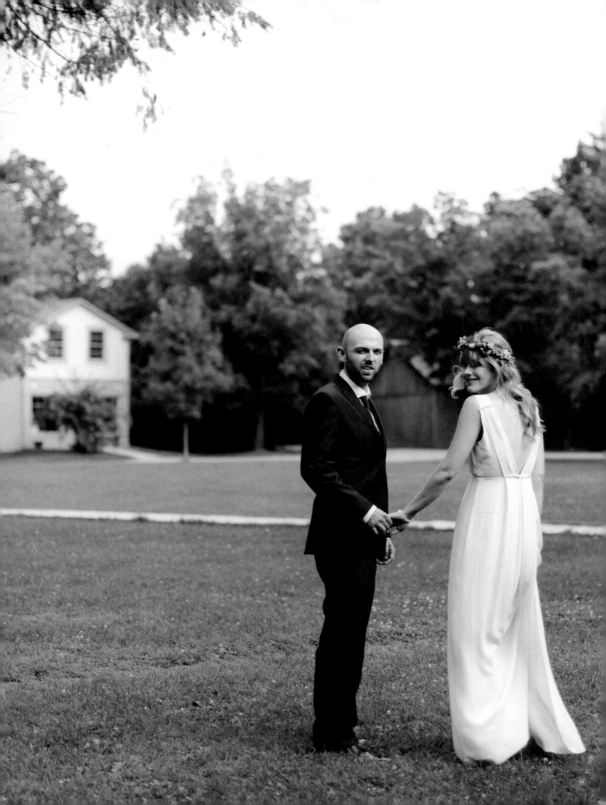

CHAPTER 10

SPECIAL EVENTS
CELINE KIM

Celine Kim is the author behind *Bonjour Celine*, a beautiful lifestyle blog that highlights snippets of her life and family, as well as weddings that she photographs. She resides in Toronto, Canada, with her husband Jin, daughter Eloise, and Mea the cat.

Couples plan their wedding for months, and when the day arrives, it goes by in a blur. My goal is to capture the events of the day as thoroughly as possible. When I curate the photos from a wedding to post on my blog, I aim to show a narrative that reflects the atmosphere of the day in a concise but expressive manner. I focus on telling a story about the couple, and the love I felt around them. Pacing the story with significant moments of the day and with quiet observations in between. In the end, the photographs should express what truly happened so those who were there will recall how they felt on the day, and those who were not will feel as though they were.

COMPOSITION AND
STYLING CHALLENGES

NATURAL LIGHT

Natural light produces the best results no matter the weather. If the weather makes photographing outside not possible, shooting indoors in a room with a window can still produce beautiful photos. Turn off all the incandescent lights and place your subject in front of a window that does not have direct sunlight coming through. You can achieve different results if you play with your position. If you shoot directly into your light source, you could photograph a beautiful silhouette of your subject with the background glowing behind them. Or if you position your subject so the source of light is coming from the side, the subject's features will be highlighted (e.g. the curve of cheekbones, definition in arms) with some dramatic shadows. If you photograph with the light behind you, the most beautiful soft light will fall on your subject.

CANDIDS

Anticipating when to take a photo at key moments takes practice, but candid photographs of people when they are in the middle of an action or expression are often my and my clients' favourite images. For example, capturing guests reacting to a touching speech or a funny moment in a wedding ceremony always makes a dynamic photo. True candid photographs are captured when the subject does not notice your presence. Using a long lens so that I am further away allows me to be discreet. For the situations where space is tight, a wider lens is more suitable. In these cases, making my presence known to the wedding guests often helps. I'll approach a group and ask to take a posed photo of them so that later when I want to capture candid moments of them naturally enjoying the wedding, they are much more comfortable with me and the camera's presence.

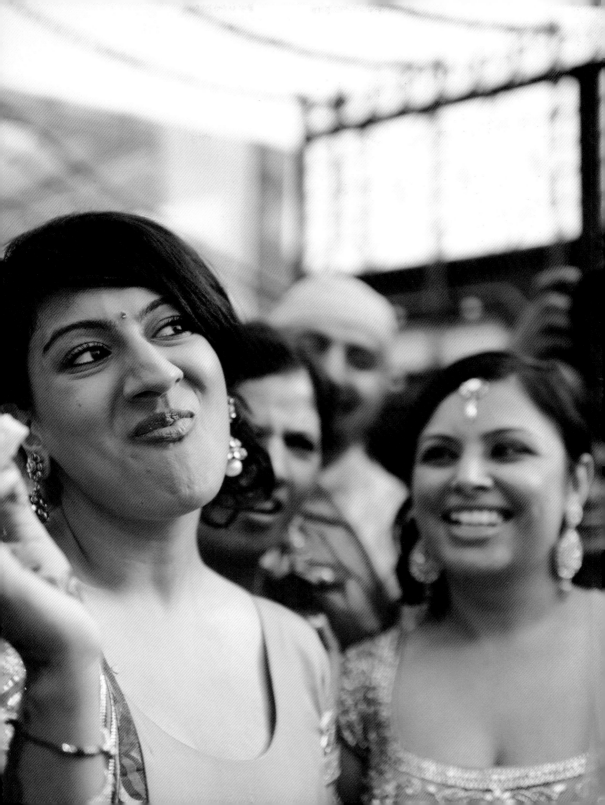

BACKGROUNDS

Train your eye to notice what is happening behind the subject you photograph; objects in the background can distract from the foreground subject and make a potentially great photograph unusable. When I am in a location where I have some control over the background—a bride getting ready in her room, for example—I quickly move furniture and clutter that may be distracting in the photograph out of the way. When outdoors, I may not have the luxury of controlling the environment. As a result, I look for neutral backdrops, such as ivy-covered walls or stone, so that my subjects are the main focus.

VARIATION OF SCALE

In order to fully capture the extent of an event, I like to photograph a variety of scales, from long range images of city landscapes to close-up shots of florals and clothing details. They are a great addition to your set of photos and complete the story of the day. Photograph details like products cropped fairly close with the subject in clear focus. Make sure the background is not distracting from your subject, and blur the background by setting your camera to a lower aperture so that your subject is really brought to the forefront of the composition.

When photographing the overall setting, whether it is an interior space or the exterior of a building, I use a tripod or prop my camera on a steady ledge. You want everything to be sharp; setting your camera to a higher aperture will achieve this result.

FLASH PHOTOGRAPHY

When natural light is no longer available, using a dedicated flash is required. There are many techniques for working with flash during an event where you are required to be mobile. My favourite technique for capturing moments where you want the photo to reflect the interior atmosphere as naturally as possible is to point the flash upwards so that it bounces off the ceiling, creating indirect illumination. This way, the light will diffuse onto both your subjects and their immediate surroundings. A bounce card also helps to propel the light forward to fill your subject in the foreground with a touch more light, while still allowing ambient light in the background to be present, keeping your photo looking as natural as possible.

Celine Kim

Blog name
Bonjour Celine

URL
bonjour-celine.blogspot.ca

Camera equipment:
Nikon D3 and D700 and prime lenses (35mm, 50mm, 85mm).

Favourite types of shots:
My favourite photographs are the ones I didn't plan. And photographing in any kind of natural light is always the best.

Favourite accessories:
On-camera flash (Nikon SB900), a flash diffuser (Gary Fong Origami), remote flash trigger (PocketWizard).

Favourite photographers:
Jonas Peterson, Nirrimi Firebrace, Famapa, Sean Flanigan, Hideaki Hamada.

Favourite bloggers:
Miss Moss, Fine Little Day, Fieldguided, My Second Hand Life.

When did you start your blog and how long have you been photographing special events? Did one of these happen because of the other?
I started the blog in 2009 because I wanted to document all the crafty things I intended to make, but I ended up taking more photos than crafting. I was hired to photograph my first wedding in 2011.

Are you self-taught? If so, what has been the most beneficial lesson to learning the art of photography?
I am self-taught but I am blessed to have met some incredible mentors along the way. I wouldn't have made it this far without their wisdom. Photography has given me a creative outlet and enabled me to share with people the ordinary things that I find so extraordinary.

What is your favourite online outlet to communicate with your fans, and how has blogging and social media helped you grow as an artist?
Blogging is my main tool to communicate with people, and Instagram comes in as a close second. Social media has allowed me to experiment with photography and I love the feedback I get from people in the community. It has also introduced me to inspiring creatives from all over the world, some of whom have become really close friends. Just surrounding yourself with other creative people inspires you to be better at your craft.

What is your favourite equipment to use?
I like to shoot with prime lenses (lenses with fixed focal lengths) and my favourite is my 35mm.

I love the raw and real state you capture your subjects in, whether it be your sweet daughter or your brides and grooms. If you had to offer three tips as to how to capture these kinds of moments, what would they be?

1. Knowing when to 'go with it'. The best time to photograph reactions is when your subject is ignoring you. Sometimes the subject is so wrapped up in their own conversation that they are not paying attention to what I am telling them to do. That is when setting up your shot can wait, as it is a great opportunity to document candid reactions. Children are probably the easiest to photograph candidly as they don't usually take instruction very well anyway!

2. Experiment and shoot a lot. Practice will help you anticipate when to press the trigger, and you will be quicker to frame a well-composed shot in those split-second moments.

3. Don't be afraid to let your inner-self come out (even if you think your real self is really weird), because that is what will make your photographs stand out from your point of view. Capture how you see the world and show everyone a little bit of what goes on inside your thoughts.

SECTION THREE

THE TECHNICAL STUFF

CHAPTER 11

GETTING YOUR PHOTOS ONLINE

Now that you have some basic information on camera types and what they can do, and have been given some of the best tips from the pros, it's time to take some photos with your newfound knowledge and share them with the world! There is also a good chance that you are already sitting on a lot of photos that you've snapped—from your smartphone or a camera you own. Either way, what comes next?

This chapter will cover the basics of getting your photos online. Learn about editing tips for improved photos, resizing images, photo storage, protecting your images and more. All of these simple tips will better your understanding of photography, and help you stay organised with the hundreds and hundreds of photos you may have in this digitally abundant world.

Kimberly Genevieve

EDITING ESSENTIALS

There are numerous image-editing software programs available, many of which are free. Free editing programs are typically on the more basic side, but they can still help enhance your images and aid in creating better-looking photos for your blog.

Some of the best advice I was given when just starting out was to shoot as close as possible to how you want your final image to look—try not to rely on editing to create your image. This includes paying close attention to composition, exposure and everything that appears in the frame. In the end, this will cut down the time you spend behind the computer screen editing.

BASIC EDITS TO IMPROVE PHOTOS

Basic edits include changing the exposure, contrast, temperature and sharpness, as well as cropping and straightening. Changing any of these elements can completely transform an image that may not have turned out how you wanted it right out of the camera. Is your photo too dark? Adjust the exposure to brighten the image. Do you want the blacks in your photo to pop more? Add some contrast!

One of the most common changes I make is adjusting the warmth or coolness of a photo, or in other words, the temperature. Temperature settings are found in all editing programs. Light, especially from an artificial source, can throw off colours and skin tones in a photo. Depending on your style and the look you desire, you can make adjustments to the temperature to represent more true-to-life colours.

FILTERS AND PRESETS

There are many filter and preset programs and apps that can transform your images. These programs are created with specific (and editable) settings to instantly change the look of your photos with a click of a button. Some examples of software and apps you could use include Instagram, Afterlight, VSCO Cam and Alien Skin.

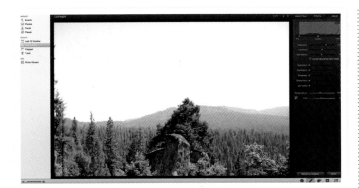

SOFTWARE SUGGESTIONS

- iPhoto (free)
- Picasa (free)
- Gimp (free)
- Aperture (£)
- Adobe Photoshop Lightroom (£)
- Adobe Photoshop (£)

SHOOTING IN RAW

A tip that may help you enhance your photos more dramatically when post-processing is to shoot in RAW format and with the largest image size your camera is capable of. This creates high-quality files that are very editable if needed. Although, keep in mind that images that are shot in RAW take up a lot more space because of their large file size.

CROPPING AND STRAIGHTENING

These are two of the simplest ways to effectively transform a good image into a great one. Using a unique crop or cropping out distracting elements will grab and hold your viewer's attention. Similarly, rotating your image so that any vertical or horizontal lines are straight and level will make your photo more pleasing to the eye.

TOUCH-UPS

Lastly, fine-tuning and making changes such as removing blemishes, red eye or odd marks on portraits are small adjustments you can make to improve the overall quality of your photos.

SEE ALSO

DSLR (see 'High quality of images and RAW mode') pp. 14–15

Camera Exposure p. 28

Colour pp. 44–45

Composition pp. 46–49

UNDERSTANDING PRINT QUALITY

Understanding print quality is beneficial if you're interested in submitting your images to be featured in a magazine/publication, or if you want to print and enlarge photos to sell or use as artwork.

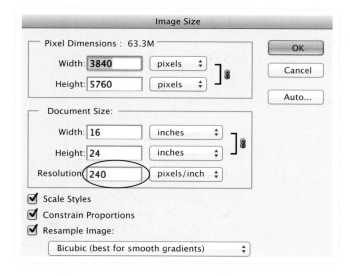

DPI AND RESOLUTION

DPI and resolution are two important terms to know and understand before printing your images. DPI stands for dots per inch—the number of dots (or pixels, aka PPI) in an inch of a printed image. Put simply, the more dots there are, the higher quality the picture is.

Resolution is how much detail there is in an image. The higher an image's DPI is, the higher the resolution is. For printing, high-resolution images are necessary.

STANDARD PRINT AND WEB SETTINGS

As mentioned in Section One, shooting in RAW and the largest image size the camera is capable of is ideal for editing as well as for printing. This ensures the image is of the highest quality with a lot of detail.

The standard DPI for printing is 300 (at the size it will be printed), and can be set when saving or exporting your image after editing. The standard DPI for web is 72 or 92, because less quality and detail is needed when viewed on a screen.

SEE ALSO

Editing Essentials
pp. 159–161

DSLR (see 'High quality of images and RAW mode') pp. 14–15

RESIZING IMAGES

Resizing images may be necessary for blogging, as most blog templates have a standard width set for image and text content (typically anywhere from 600px to 800px). If shooting in RAW, you will most likely have to scale down your images because they will be very large in file size.

SAVING OR EXPORTING

After editing an image, it can be saved/exported at a specific size. This is a good method if you want your image(s) to be blog-post ready. However, after decreasing the size of a photo, you will not be able to enlarge it with the same quality (resolution) in the future. If a larger image is needed, you will have to open the original image in your editing program again and re-save/re-export the image at the new size.

IMAGE HOSTING

Another option for resizing is uploading your edited photos at the original size to a hosting site such as Flickr. On Flickr, you can choose different image sizes to use for the web. Some blog services automatically compress images when posted—this reduces the quality, clarity and sometimes colour. Using an image host is good because the original, high-quality photo is utilised when posting, not a compressed image.

SEE ALSO

DSLR (see 'High quality of images and RAW mode') pp. 14–15

Understanding Print Quality p. 162

Image Compression p. 164

163

IMAGE COMPRESSION

Compressing an image is essentially reducing the image's data and file size. This reduction of size can be done with or without losing image quality, known as 'lossy' and 'lossless' compression, respectively. Compression of images saves storage space/memory and makes transferring images faster. Lossy compression results in smaller file sizes.

COMPRESSION FILE FORMATS

Some of the most common image compression file formats you will see are JPEG, PNG and TIFF. Deciding what you will be using your images for is the first step to determine what file format you will need.

JPEG
- The most common image format for web
- Lossy (may be best to save the original file on top of a JPEG for future edits)
- Ideal for web, transferring images or sending images via email

PNG
- Lossless
- Large file type
- High quality
- Ideal for web
- Supported in all web browsers

TIFF
- Lossless
- Extremely high quality
- Ideal for print

SEE ALSO

 Image Compression p. 164

 Protecting Your Images p. 166

STORAGE AND BACKUP

In today's digital world, image and data organisation can be challenging if you don't have a method to store and back up your information. Everyone has a different way of photo management—finding a way that works best for you is key!

STORING AND ORGANISING IMAGES

One of my top priorities is a computer system that functions fast, so I prefer storing most of my data on an external hard drive so that my internal hard drive doesn't slow down for having too much data on it.

BACKING UP IMAGES

Whether you store your images on your computer or an external hard drive, having a backup system for your photos will prevent any chance of data loss. Consider having an additional hard drive for backup, or using a cloud. Cloud services, such as Backblaze, are great if you travel often or need to access your work from different computers, because your info is stored online rather than on a hard drive.

165

PROTECTING YOUR IMAGES

Photo theft is a common occurrence on the internet. After working hard on creating and editing your photos, theft of your work is one of the last things you want to happen. Below are three options you can use to protect your images from being stolen.

WATERMARKING

A common method for preventing the theft of your work is watermarking. Watermarks are essentially a visible (sometimes opaque) 'stamp', typically a logo, placed somewhere on your images. This can prevent someone saving and using, printing or selling your images. Programs like Lightroom and Photoshop make it easy to apply a watermark when saving and exporting your edited photos.

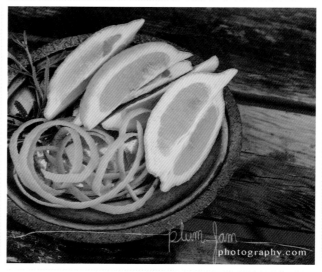

Plum Jam Photography

DISABLE RIGHT-CLICK OR DRAG AND DROP

Another way of preventing theft is disabling the 'right-click' or 'drag-and-drop' options on your photos. This method is a little bit more complex because it requires specific javascript to be added to your blog template's HTML section. Check the relevant documentation for your blog platform for instructions.

LOW-RESOLUTION IMAGES

Using low-resolution, compressed images can also prevent others from stealing and reproducing your work. A low-res image cannot be enlarged and printed without being grainy and possibly blurry.

SEE ALSO

 Resizing Images p. 163

 Image Compression p. 164

GLOSSARY

Analogue (camera)
A non-digital camera that uses film instead of an electronic sensor.

Aperture
The size of the hole in a lens in which light passes through. Aperture controls depth of field and is measured in 'f' numbers, also known as f-stops.

Aperture priority (A or AV)
A semi-manual mode on most cameras that allows the user to set the aperture while the camera adjusts the shutter speed to create good exposure.

Automatic
A mode in which the camera chooses all the settings to create an 'ideal' exposure for your image.

Bokeh
The out-of-focus or intentionally blurred-out area in a photo, often created to bring focus to the subject.

Bounce card
A reflective piece of card used to help redirect and soften the light from the a flash unit.

Colour temperature
The overall hue or colour cast of a photo created by differing light sources. Colour temperature is measured in Kelvins.

Complementary colours
Colours that work together to create contrast that can be pleasing to the eye.

Compression
The process of reducing an image's data or file size. This reduction of data/size can be done with or without losing image quality.

Depth of field
The area or range of distance in a photo that is sharp and in focus.

DPI (dots per inch)
DPI measures resolution and is the number of dots in an inch of a printed image. See also PPI.

DSLR (Digital Single Lens Reflex)
A digital camera that can produce high-quality images and video with the ability to give the user complete manual control and the option of interchangeable lenses.

Exposure
The amount of light that is let in by the camera's sensor when taking a picture.

Flash diffuser
An accessory that can be attached to a camera's flash to spread the concentrated light it produces to create a softer light.

Freelensing
A digital camera technique to create 'artistic' and unique photos that involves detaching the lens from the camera body and shooting through it (the lens) at different angles.

F-stop
The measurement of the aperture setting, which controls how much of the image is blurred and how much is in focus. The lower the f-stop, the more light is let in through the lens, and the more 'blur' there is in the image.

Golden hour
Also known as the 'magic hour', the golden hour takes place during the first hour of sunlight in the day and the last hour before the sun sets. It is known to be one of the most favorable times to shoot because the light from the sun is softer and creates a warm glow.

Image-hosting (service)
A service that allows users to upload images onto a website that stores them on its server and provides public photo viewing and codes for photo sharing.

ISO
The film speed or the sensitivity of a camera's sensor to light.

JPEG (or JPG)
A common image file format that is created when an image is compressed.

Leading lines
A compositional technique that uses lines to direct the viewer's eye towards the subject.

Light box
A mini 'photo studio' in the form of a box that is used to create professional-looking close-up images of products (or small subjects). A light source is evenly diffused through semi-transparent material into the box.

Light leak
An 'artistic' effect created on an image (negative) when a hole or space is present in an analogue camera body that allows light to pass through and reflect on the film.

Light meter
A common photography instrument that measures the amount and intensity of light. It not only measures light, but calculates the correct exposure to aid a photographer when choosing camera settings.

Light reflector
A common photography accessory used to control and redirect natural and available light.

Light trails
A popular subject matter that is photographed by using a tripod and long shutter speed to capture the movement (or 'trailing') of lights, typically at night.

Lomography
A popular analogue/toy camera movement and community.

Lossless
A type of compression that reduces the file size of an image without compromising the image quality. This results in larger file sizes, but retains good image clarity and colours.

Lossy
A type of compression in which the original file is affected and image data is lost. This type of compression dramatically reduces an image's file size and, in turn, reduces the image quality.

Macro
A mode on some cameras (or a lens) used to capture extremely close-up details of an object.

Manual (M)
A mode on most cameras that allows the user to have full control over all settings.

PNG
A common image file format that is ideal for publishing images online.

Post-processing
Another term used for editing an image.

PPI (pixels per inch)
PPI measures resolution and is the number of pixels in an inch of a digital image. See also DPI.

Program (P)

A mode in which the camera chooses aperture and shutter settings to create an 'ideal' exposure for your image. Program mode allows users to manually change other settings such as flash, ISO and white balance.

RAW

A large uncompressed file format that contains minimally processed data to enable detailed post-processing/editing.

Resolution

How much detail there is in an image.

Rule of thirds

A compositional guideline in which the subject of a photo is placed in certain parts of a hypothetical grid. The grid breaks a photo up into nine different sections in total, and the ideal subject placement is on one of the grid lines or points where the lines intersect.

Saturation

The richness or intensity of a colour.

Shutter priority (S or TV)

A semi-manual setting on most cameras that allows the user to set the shutter speed while the camera adjusts the aperture to create good exposure.

Shutter speed

The amount of time in which a shutter of a camera opens and closes.

TIFF

A large image file format commonly created and used if high-resolution images are needed for printing.

Watermarking

A watermark is a visible (sometimes opaque) 'stamp', typically a logo, placed somewhere on an image. Watermarking can prevent someone from saving and using, printing, or selling your images.

White balance

A setting in digital cameras that controls the colour temperature in photos.

ONLINE RESOURCES

PHOTO-SHARING SITES

500px 500px.com

Flickr www.flickr.com

Photobucket photobucket.com

Picasa picasa.google.com

SmugMug www.smugmug.com

SOCIAL MEDIA SITES

Facebook www.facebook.com

Pinterest www.pinterest.com

Twitter twitter.com

BLOG PLATFORMS

Blogger www.blogger.com

Squarespace www.squarespace.com

Tumblr www.tumblr.com

Typepad www.typepad.com

WordPress wordpress.org

PHOTO/VIDEO-SHARING APPS

Instagram instagram.com

Vine vine.co

PHOTO/VIDEO-EDITING APPS

A Beautiful Mess www.abeautifulmess.com/a-beautiful-mess-app

Afterlight afterlight.us

Snapseed (via App Store or Google Play)

Vsco Cam vsco.co/vscocam

OTHER APPS

Camera+ campl.us

Rise—The Sunrise Sunset Calendar (via App Store or Google Play)

TimerCam (via App Store or Google Play)

PHOTO-EDITING SOFTWARE

Adobe Lightroom www.adobe.com/products/photoshop-lightroom.html

Adobe Photoshop www.photoshop.com

Alien Skin Exposure 5 www.alienskin.com/exposure

Aperture www.apple.com/aperture

Gimp www.gimp.org

VSCO Film vsco.co /film

PHOTO PRINTING

Artifact Uprising www.artifactuprising.com

Blurb www.blurb.com

Overnight Prints www.overnightprints.com

Pinhole Press pinholepress.com

Shutterfly www.shutterfly.com

Snapfish www.snapfish.com

CLOUD SERVICES

Backblaze www.backblaze.com

Dropbox www.dropbox.com

Google Drive drive.google.com

iCloud www.icloud.com

INDEX

INDEX

CONTRIBUTORS

Ann Nguyen, **Lost & Found Photography**
lostfoundphoto.com

Annie McElwain and Raya Carlisle,
Lovechild Photo
lovechildphoto.com

Ashley Ludaescher
ashleyludaescher.com
chasingheartbeats.com

Ben Blood
benblood.com

Caroline Hancox
carolinehancoxweddings.com

Cassie Pyle, **Veda House**
thevedahouse.com

Celine Kim
bonjour-celine.blogspot.ca
celinekimphotography.com

Connie Lyu, **The Great Romance Photography**
thegreatromancephoto.com

Dabito
oldbrandnewblog.com
instagram.com/dabito

Diane Leyman
notestoafurtherexcuse.com

Fawn DeViney
fawndeviney.com
fawndeviney.tumblr.com

guremike
guremike.jp
instagram.com/guremike

Joshua Thompson

Kimberly Genevieve
kimberlygenevieve.com

Leila Peterson
leilapeterson.com/blog
instagram.com/dearleila

Michael Young

Michelle Lau
aminuteawayfromsnowing.com
instagram.com/aminuteawayfromsnowing

Oana Befort
oanabefort.com
instagram.com/oanabefort

Shannon Moore, **Plum Jam Photography**
shannonmoorephotography.com
plumjamphotography.com

Tamsin Richardson
thisgirltj.blogspot.co.uk

Tara O'Brady
sevenspoons.net
instagram.com/taraobrady

Tori Hancock
torihancock.com
welliesandvogue.com

ACKNOWLEDGEMENTS

A heartfelt thank you goes out to each and every one of you who have helped make this book become a reality. Thank you especially to the RotoVision team and editors—namely Isheeta Mustafi, Tamsin Richardson, and Ellie Wilson—and to all of my wonderful contributors—Tara O'Brady, Oana Befort, Konno, Dabito, Leila Peterson, Michelle Lau, Celine Kim, Ann Nguyen, Annie McElwain, Ashley Ludaescher, Caroline Hancox, Cassie Pyle, Connie Lyu, Diane Leyman, Fawn DeViney, Kimberly Genevieve, Michael Young, Raya Carlisle, Shannon Moore, and Tori Hancock—for sharing so much of your talent, time, effort, and beautiful work. Thank you to my dear family, friends, photo mentors, and creative community for all of the continuous love and support you've given to me throughout my life in constantly pursuing my passions. To everyone I know and have had conversations with that have lead me to where I am now, thank you.

And lastly, to Josh, I wouldn't be here without you. Thank you for being the most supportive husband, friend, and mentor, and for encouraging me to follow my heart. I dedicate this book to you!

Find Jennifer at:
iartublog.com
jenniferyoungstudio.com
instagram.com/iartu_jennifer